THE SPIRIT OF

SAAB

50 REASONS WHY WE LOVE THEM

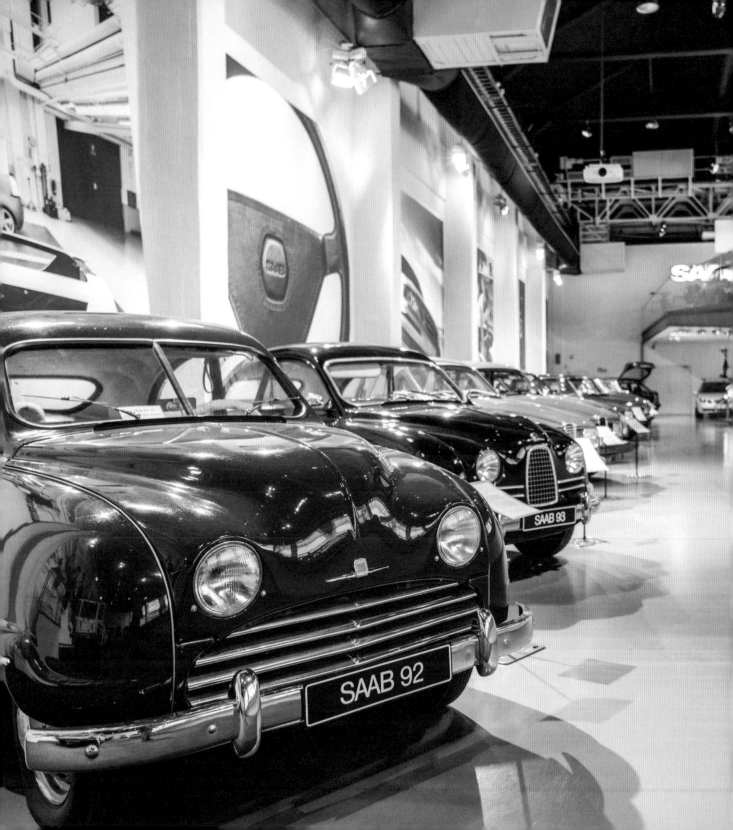

THE SPIRIT OF

SAAB

50 REASONS WHY WE LOVE THEM

Vaughan Grylls

BATSFORD

CONTENTS

INTRODUCTION

The Spirit of Saab

This is not a technical book. It is about the spirit of Saab, a stylish car manufacturer, now sadly out of business for over a decade.

Saab was never a large company. It was set up by Svenska Aeroplan AB, or Swedish Aeroplane Corporation, at the end of the Second World War, as a commercial diversification when it was clear that the market for military airplanes was in serious decline.

By 1949 the company's first motor car rolled off the production line – the curiously designed Saab 92, although it wasn't as unusual as its prototype, the Ursaab, which certainly looked like the offspring of an airplane company. If wings had been added, it could have taken off.

The sleek Ursaab sported elegant covers over its wheel arches. Unfortunately, they jammed with ice in the winter. You would have thought Swedish airplane designers would have thought of that – or maybe not, since planes usually land on ice-free runways.

In 1969 Svenska Aeroplan became Saab-Scania when it merged with Scania-Vabis, the Swedish bus and lorry manufacturer. Twenty-one years later, Saab-Scania separated its car division into an independent company, obliging the carmakers to fend for themselves. On the face of it, this was a strange decision, as the best-selling 900 Turbo had come to define the carmaker's worldwide image. Yet even the 900 models failed to make enough money to reinvest in extensive research and development to match that of its rivals – status manufacturers such as Audi, BMW and Mercedes. Margins had been kept low at Saab in order

The Ursaab prototype, 1947.

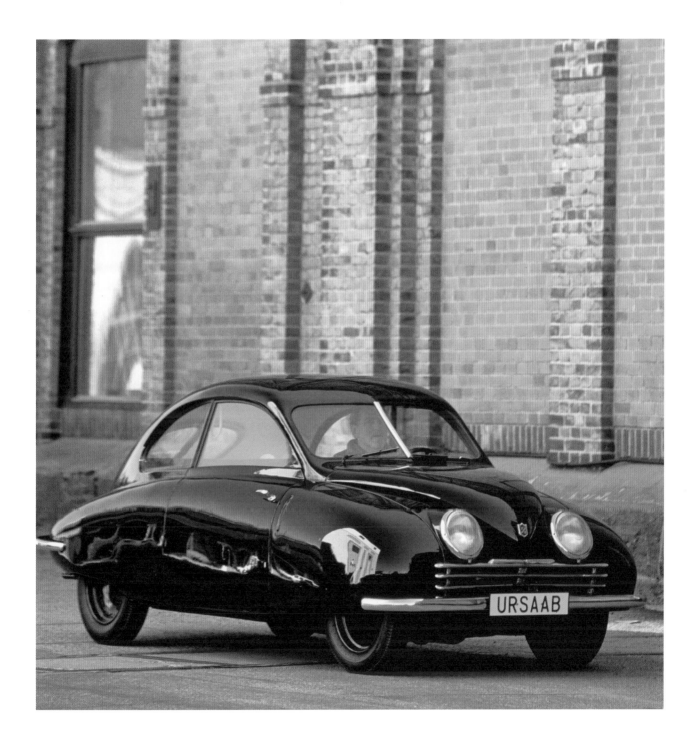

SWEDISH SAFETY ENG

STRONGER, SAFER BODY SHELL
Extra heavy-gauge sheet steel (approx. 15% thicker than in other cars of similar size) adds strength and rigidity to the streamlined body shell.

PASSENGER SEAT CATCH
A retaining catch on the passenger seat prevents the seat back from folding forwards if the car is braked suddenly.

EXTRA-REINFORCED WINDSCREEN PILL
There's invisible st the slim windscree They are reinforced cial steel sections deep down into the

LONGER LUBRICATION INTERVALS
New lubrication system permits 6,000-mile intervals between servicing.

SAFETY LOCKS ON DOORS
Door locks of safety type with catches to keep doors closed even under the severest strains.

PADDED SUN VISORS
Safety-type sun visors incorporate a core of shock-absorbing plastic to reduce risk of head injuries.

REAR FUEL TANK
The fuel tank is safe and well-protected at rear of car.

QUIETER
A new exhaust system reduces engine noise.

DUAL BRAKING SYSTEM
Each system acts on one front wheel and the diagonally opposite rear wheel. Damage to one system leaves the other in full working condition and the diagonal configuration minimises the risk of skidding.

UNDERBODY COATING
Standard on all SAAB cars, underbody coating is applied directly to the anti-corrosion treated sheet steel before the car is painted –– adds greatly to life of bodywork.

NEW HEATING SYSTEM
Faster heating and a wider range of adjustment provided by the new heating system.

EERING

AFETY ZONE IN WINDSCREEN
windscreen shattered by flying
ones won't leave you blind and
elpless – – vision and safety remain
nimpaired.

HBOARD
board for

NT PEDALS
pedals keep out
, dust and dirt.

3-CYLINDER, 2-STROKE ENGINE
Even more power delivered by the
rugged and reliable two-stroke.

NEW COOLING SYSTEM
Radiator located in front of en-
gine for more efficient cooling.

SELF-ADJUSTING BRAKES
Front brakes are self-adjust-
ing. Correctly adjusted brakes
at all times are vitally impor-
tant to safety.

FRONT WHEEL DRIVE
Front wheel drive pulls the car round
corners as if on rails – – safer driving
on loose gravel or other slippery
road surfaces. Engine at front, placing
weight right over the traction wheels.

COLUMN
ng column
ere collision
driver.

to allow the model to compete with these marques, who always had
the advantage of volume to control costs.

So how could a worthy successor to the 900 be developed? Not
by the parent company, which had been underwriting the carmakers
from the beginning. Saab Cars had continually struggled to survive on
its own. In the 1980s, a deal was done with the Fiat conglomerate to
design a luxury Eurocar, the new Saab 9000-cum-Alfa 164/Fiat Croma/
Lancia Thema. It was an uneasy relationship. Saab upgraded their
version mainly on safety grounds, citing the Fiat offerings as being far
too flimsy in a collision to carry the Saab badge. In doing so they eroded
any profit margin.

In 1989, General Motors (GM) stepped in and bought a 50 per cent
holding for $600 million. GM were an odd partner, yet the only one
willing and able to risk such serious money. But over the next decade
Saab still didn't turn a respectable profit. GM had to decide either to
walk away or take 100 per cent ownership, as they were entitled to do
under the terms of the deal. They decided to buy the whole company.

Since their original investment, GM had been attempting to cut costs
by using GM platforms, such as the Opel Calibra and Vauxhall Cavalier.
As had happened with Fiat, Saab designers were sniffy, subverting the
cost savings by putting in their own enhancements.

That was to be expected. Saab's designers had never had the
approach of price-point first. They were dedicated designers, trying

desperately to hang on to those things that made a Saab a Saab. Their approach was more like that of a tiny, bespoke car manufacturer, such as Aston Martin, Bristol or Jensen – hand-made cars designed and built, regardless of cost, for the rich and discerning. The problem was that Saab was now a mass manufacturer competing in a world market.

GM put their foot down. To make any money at all, Saab must become a fully fledged GM division with an upmarket badge if it was to survive.

In doing so, GM deliberately ignored Saab's long-established target market – those who bought Saabs because they were original and idiosyncratic, for that was how traditional Saab buyers saw themselves.

Even though these new GM-inspired Saabs were easier to drive and – whisper it – more modern, this actually made them less desirable for these educated, discerning Saabists who were motivated in life by vocation ahead of financial security and ease of life. Here were the architects and media types, scientists and engineers, pilots and publishers. The problem for GM was that, even lumped together, there were just not enough of them in the world to support a volume car maker such as Saab in an increasingly competitive world market.

Saab had to join the mainstream. And that begged a question. Even though Saab was producing some brilliant cars such as the 9-5, would there be enough of the non-Saabists, the main-streamers, willing to buy a Saab when they could have a BMW for the same price?

The answer was depressingly obvious.

GM gave up. They tried to sell the brand to Spyker, NEVS (National Electric Vehicles Sweden) and even Koenigsegg. Spyker took an interest, but that was short-lived. NEVS finally bought the factory. And so, one extremely sad day in 2011, Saab folded. Rather like the smile on the face of the Cheshire cat, only the cheerful Saab Museum remains at Trollhättan. Should you ever be in Sweden, do visit. Here you will find examples of all the cars Saab ever designed.

Saabs are wonderful because their best models blend Swedish design engineering with the soul of a classic Italian car. Who else has done that? Original, sometimes eccentric, yet always thoroughly thought through, the Saab spirit has made a unique contribution to the development of the motor car.

And here are 50 reasons why we love them …

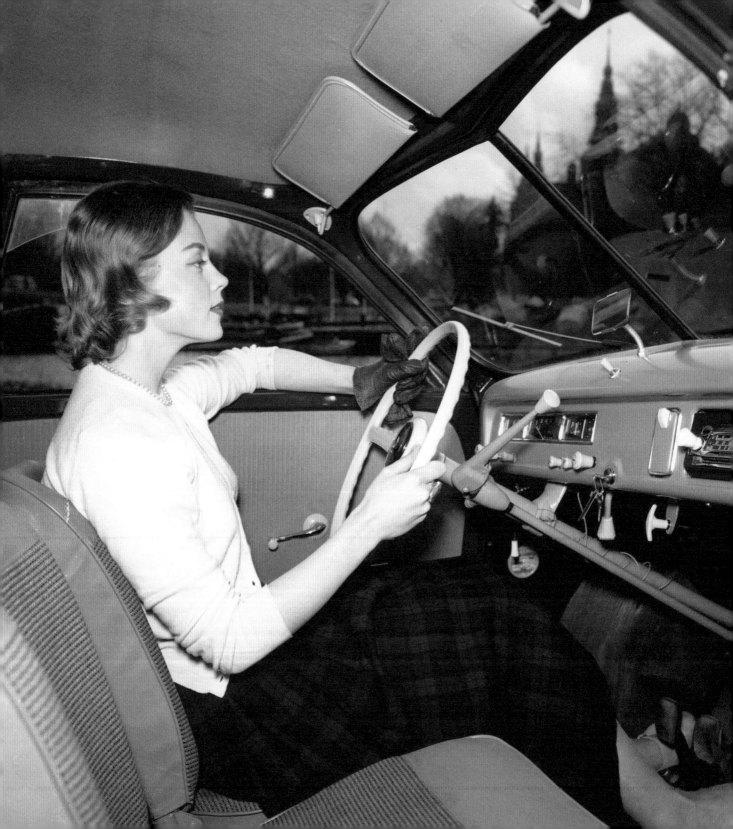

01

THE SAAB IMAGE

From the very beginning, Saab meant Cool.

Why was a Saab cool? Well, for one thing, a Saab was sexy without being sexist at a time when most motors were macho.

No Saab was macho, even those mud-splattered, rallying ones with racing labels stuck everywhere – cars that first made the Saab name stick in the public imagination.

This ad pic comes from 1952. Women in car ads were popular then, and would continue to be right through to the 1980s. Except most showed a woman in the passenger seat and the man at the wheel, except when she was draped over the hood. Not Saab.

But it wasn't just the unisex image – presented before that word was invented – that made Saab intriguing. It was the cool design: the lack of extraneous decoration, the concentration on functionality expressing the modernist, Bauhaus-inspired ethic of form following function.

A Saab demonstrated the difference between design and styling. A stylist adds the style to the engineering, but a designer marries the engineering with the aesthetics from the beginning, rather like an airplane designer. And of course, Saab was first an airplane company.

And how cool are those leather gloves?

A woman driving a
Saab 92, 1952.

02

THE COOL TEST

Here is a Saab driven by the photographer's wife as she wends her way through the darkening streets of South London, sometime in 2007. There may not be much going on in this picture, but that is the minimalist point – lots of moody abstraction captures the cool mood of Saab.

The dashboard says a lot too; unlike many nowadays, it is no funfair. Instead, we have a soft, impressionistic glow.

Do they own this Saab? You'd expect so. And are both of them professional photographers? Probably that too, seeing as photography combines art with science.

Just like a Saab – and a good reason to own one.

The interior of a
Saab in motion.

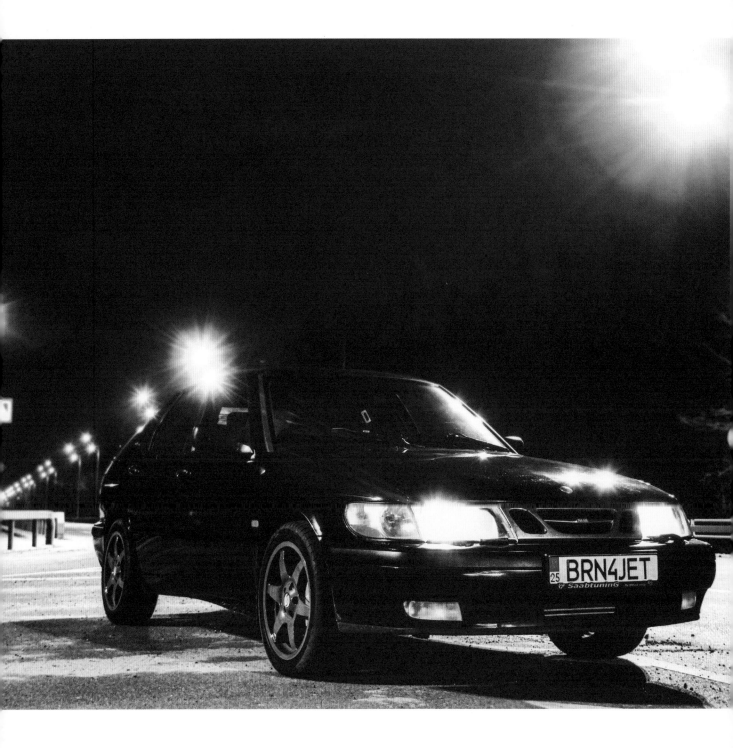

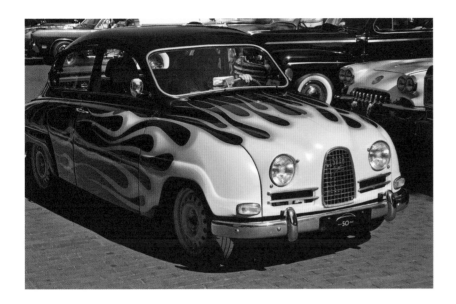

03

LOOK AT ME!

Saabs have always been understated. And in the overstated world of the car, understated is rare. As is Saab, and becoming more so as the years pass.

Here is a 1960s Saab 96 in full psycho-paint. No, not very Saab. And then a 2001 9-3 Turbo in sober-sides black.

So, you are in the driver's seat at, say, the traffic lights. In which car will you go unnoticed? And if you are noticed, which will attract looks? Respectful ones?

Saab owners have never wanted to attract attention or, even worse, look as though they are trying too hard.

Respect is an entirely different matter.

Opposite: The Saab 9-3 Turbo.
Above: A customized 1964 Saab 96.

04

CUSTOM SAAB

Customizing cars is a popular pastime, especially in America, where some weird and wonderful custom jobs are created. The original car is merely the starting point, and the finished product ends up looking as if it is ready to drive around Mars. As we have said, 'Not very Saab,' but that doesn't put off the true enthusiast who can either get the spirit of Saab and play with it in an interesting – even provocative – way, or think, 'To hell with that. I'm just thinking Mars.'

Mercifully, there are not many who do think 'Mars' with Saabs, and anyway, I'm not showing any of their products because this book is respectful of the marque, as it is of those who love it.

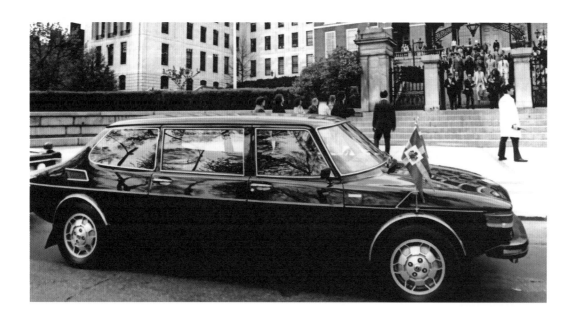

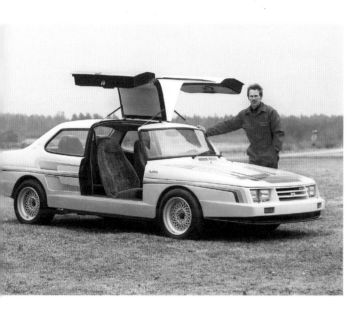

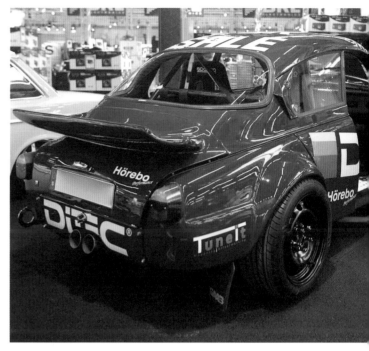

Anyway, here is a 96 that could be the progeny of a Porsche and a Saab thanks to Swedish tuners Hörebro Performance. I find that pretty interesting, because there were existing similarities between the marques in shape and rallying prowess. Then there is this 1976 EMS two-door sedan, complete with gull-wing doors (above left). Named *Blue Spirit* by the late Leif Mellberg, seen here with his creation which he completed in 1982, this car looks almost capable of flight.

And finally, we have the 5.2m, seven-seater limousine, cut and shut from two Saab 99s, a four-door and a two-door (opposite). It was ordered by the Saab company itself from Heinels in Sweden.

Before you throw up your hands in horror, I need to tell you something.

This car was made for Carl XVI Gustaf, King of Sweden, for His Majesty's official visit to the United States in April 1976. Here it is outside the Massachusetts State House in Boston. Some years ago, the king's limo was rediscovered and personally restored by Martin Bergstrand, vice-chair of the Saab Club of Sweden. People like Martin are the keepers of the spirit of Saab.

Opposite: The Saab limousine.
Above: *Blue Spirit* customized Saab.
Above right: Saab 96 customized by Hörebro Performance.

05

STRANGE ... EVEN FOR SAAB

This little yellow car looks a bit like a toy, maybe because there is an outsize photo behind of three people admiring it. I am reminded of the home-made car toys I used to buy in South Africa to bring home to my children.

Here was Saab's first attempt in 1975 at an all-electric car. Actually, it was intended to be an experimental delivery van for Sweden's Royal Mail. The only connection to the cars is the front end, which was taken from a Saab 99. This prototype is on display at the Saab Museum. If you get bored by the TV you can swivel your Saab seat around and admire this van at your leisure.

Prototypes were a thing at Saab, but they usually didn't have the resources to put all their excellent ideas into production, although one prototype managed to end up in *Back To The Future Part II*.

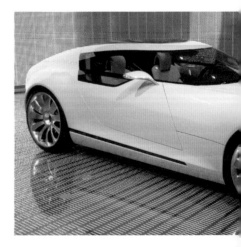

At the other end of the cool scale are Saab's concept cars. Saab had its aero division, named after its airplane heritage, and applied the name of cars made by the company's SPG, or Special Performance Group.

Here is the 2006 Aero X, designed to run on ethanol. In 2008, Saab presented its 9-X Air Biohybrid. This is the convertible, or cabriolet version as Saab called them, and is a plug-in.

What a crying shame these Saabs didn't make it into production. When I see these two beauties, it makes me almost tear up. Am I alone in this?

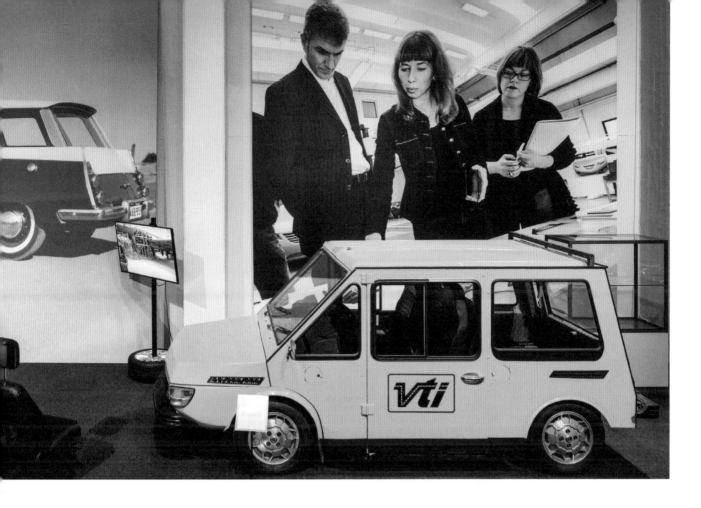

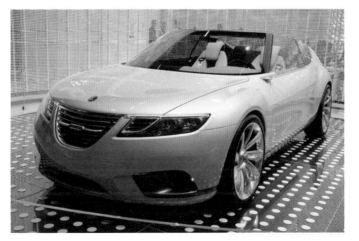

Clockwise from above:
Saab electric car
prototype in the Saab
Museum, Trollhättan,
Sweden; Saab 9-X
Air Biohybrid on
show in 2008; Saab
Aero X, 2006.

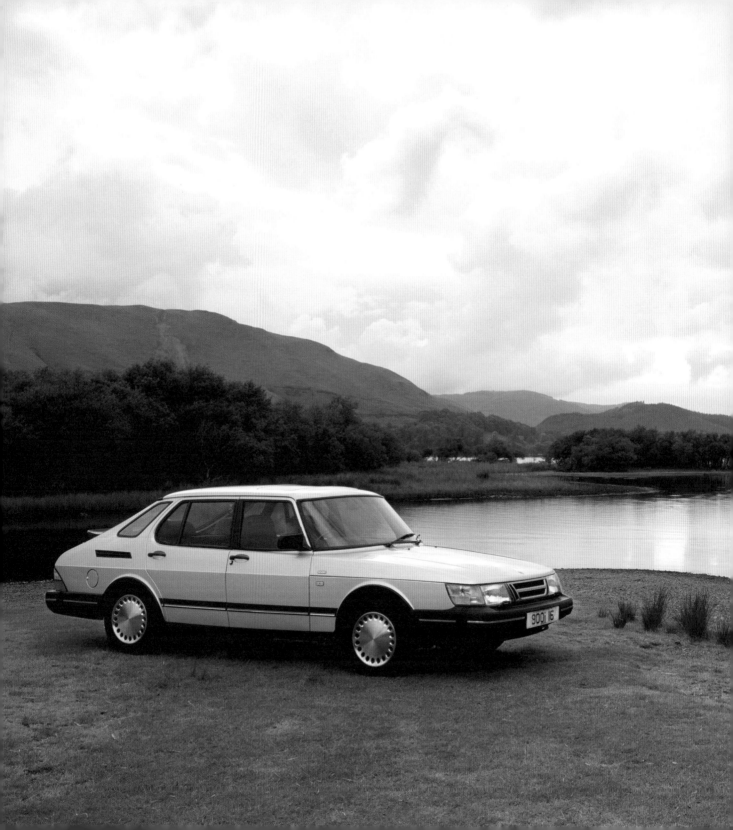

06

THE RIGHT BACKDROP

Car ads always seem to overstate their case. In the 1950s and 60s, ads for American cars showed passengers as small people, making the cars look enormous.

Later, the object of desire was seen driving along a beach or through a flurry of snow, picking up salt to help rot the undercarriage – although you were not expected to think about that.

Saab was less vulgar because they were appealing to the super-intelligent, or so they said. We'll take a look at a Saab ad or two later in this book to prove how right they were.

This photo sums up what a typical Saab owner was about. Here is a 1980s 900 16-valve, a four-door in classic white and sporting a spoiler. This image puts you in the picture, even though you aren't actually in it. That's because it implies you are its owner and have taken the shot.

Where is it? Sweden? Scotland? Slovenia? That really doesn't matter. You, its owner, are international, together with the lake, the hills and the coolest car in the world.

This, then, is the backdrop of choice for you and your Saab.

07

DISSING SAAB

It's been fun dissing certain makes of car ever since Henry Ford had
success with his invention of the car production line over a century ago,
which meant all-comers could buy a Model T. Indeed, a longitudinal park,
104 miles long, the Taconic Parkway in New York State, was built to enable
you to drive your Model T from one end to the other and back again just
for fun, so you could experience the countryside without walking.

 We can all be jealous of success. Especially quirky success. 'Four
wheels and a board make a Ford,' used to sneer the dissers. The same
happened to the Volkswagen Bug or Beetle, because, like the Model T,
it sold better than any other model in the world, and by far.

 When Saab hit the market, nobody knew what they were — or who
they were for. But then they started winning rallies like Monte Carlo and
everyone looked up. Here is an example of one of those rally-winning
models, long abandoned in a field in Iceland. I think it looks rather
beautiful, even in its forlorn state.

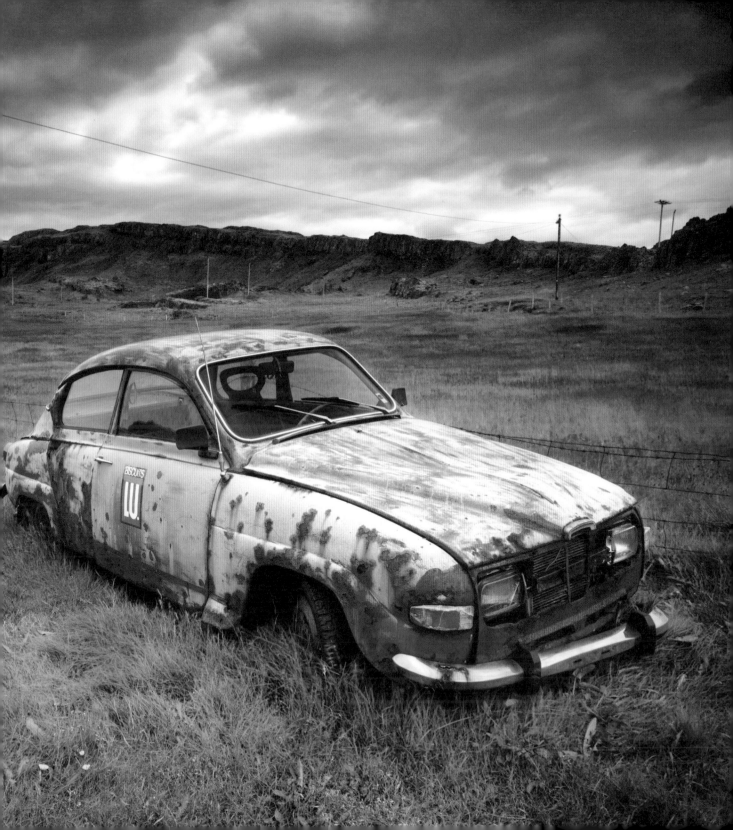

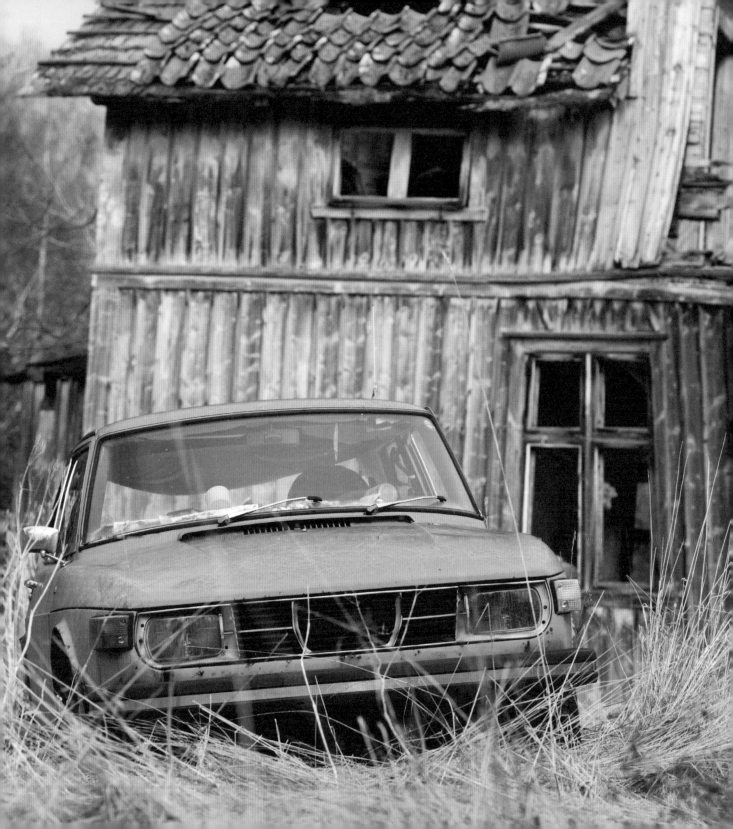

In the 1970s, along came the Saab 99, and then everybody knew what a Saab was about. Here is an abandoned 99 and an abandoned house to go with it, somewhere in Scandinavia. Two fixer-uppers for the price of one.

The 99 was developed into the superb 900 Turbo and suddenly Saab was about as cool as it was possible to be. Which made them okay to make fun of. But when GM took over and Saab slipped slowly towards the mainstream, gradually becoming less quirky, the dissing stopped because they were no longer annoying anybody.

08

GO COMPARE

Opposite: the Mercedes CLK Cabrio.
Below left: the BMW 650i Cabrio.
Below: 2003 Saab 9-3 Aero convertible.

Here are three dropheads representing three different eras in the last 30 years. The era each car comes from doesn't matter, because dropheads don't date. Funny, that.

Who is buying here? People with money, but not willing or able to acquire an Aston Martin, Ferrari or Porsche? Perhaps, but not entirely true, as these three cars are full four-seaters. Let's say they appeal to the less selfish, who are just fine about having more than one passenger in their dream machine.

If these cars are about image and wind-in-the-hair, what do their owners say to us? Something like ...?

Mercedes: I am successful. I support the status quo.
Saab: I am successful. I question the status quo.
BMW: I am successful. What is the status quo?

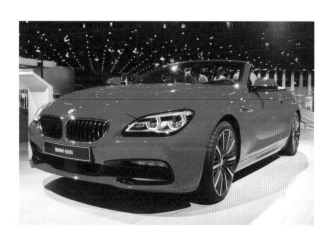

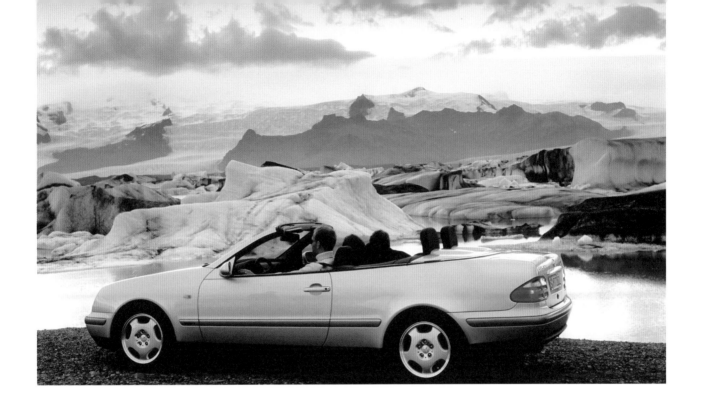

In the 1980s Saab's American distributer, Robert J. Sinclair, asked the American Sunroof Company to design a prototype drophead. Saab themselves had been hesitant as it meant an expensive investment. So, a cabriolet conversion of their 900 three-door fastback was made at Trollhättan. But it just didn't look right.

The conversion of the two-door sedan, however, did. It was made at Saab-Valmet in Finland. It also won out on rigidity – a challenge when removing the original roof and replacing it with hidden body stiffeners to minimize scuttle-shake.

Saab had also been hesitant because they were doubtful whether their type of customer would want this type of car. Intelligence married to hedonism? How would that sell?

But when they were exported to America, they sold like hot cakes, because in America you can be anything you want to be, mixed message or not. Intelligence and hedonism? No problem.

As with other things American, the rest of the world soon followed in lusting after a Saab cabriolet. Including me.

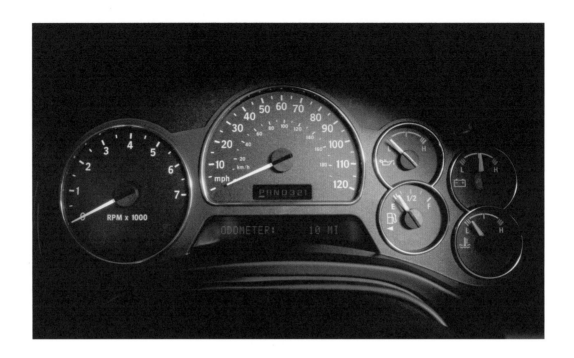

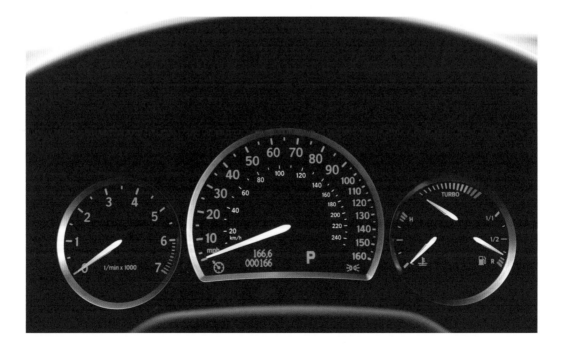

09

SAFE AND SPEEDY SAAB

Since the establishment of Saab's rallying pedigree, followed up by the smash-hit 900 Turbo, a Saab has had the reputation of being no slouch. Not necessarily in maximum speed, but in the middle range where passing slower vehicles safely is imperative.

This was a great selling point for Saab, as it foregrounded two normally opposite characteristics, safety and speed. This appealed to Saab's target market: educated if contrary types who appreciated that two plus two didn't always equal four.

Saab's blending of safety with speed lasted for most of the company's history. But then GM decided Saab could be a great badge for one of their range of SUVs. And so, a Saab 9-7X was slotted in between a Chevy Trailblazer and a Cadillac Escalade.

Here is a pic of its speedo calibrated to 0mph with a tacho.

Here is also a pic of the same bit of dashboard on a Saab 9-3 speedo, but calibrated to 160mph with a tacho complete with red lines and also with turbo instrument, also with red lines.

Both cars are from 2005/06, but only one keeps the spirit of Saab. Safety with speed.

Opposite, above: Saab 9-7X speedo.
Opposite, below: Saab 9-3 speedo.

10

PARKED SAAB

How many times, when you are distracted, or just plain normal, do you leave a shopping mall pushing a full shopping cart that will not go where you want it to go? Also, where did you park your car?

If you are about 13, you will have an app to supply the right information. But you aren't 13 and all these cars look the same. Hatchbacks and obese SUVs everywhere, except that recreational vehicle over there.

Then you catch sight of an unmistakeable silhouette: rounded roof, slim girth. But mine's a, er, Hyundai? Yes, that's what it is. Or is it a Kia? Anyway, I now remember parking near a Saab. Something like V4, it said on it. I hadn't seen one like that before.

If this isn't a good enough reason to sell that Korean thing that goes so perfectly you've forgotten what it's called, and buy an old Saab, I don't know what is. Or you could take out your phone next time and snap where you are, before rushing off into an anonymous shopping mall. Except you'd forget to do that.

Here is a parked Saab 96 V4. Please take note.

A parked Saab.

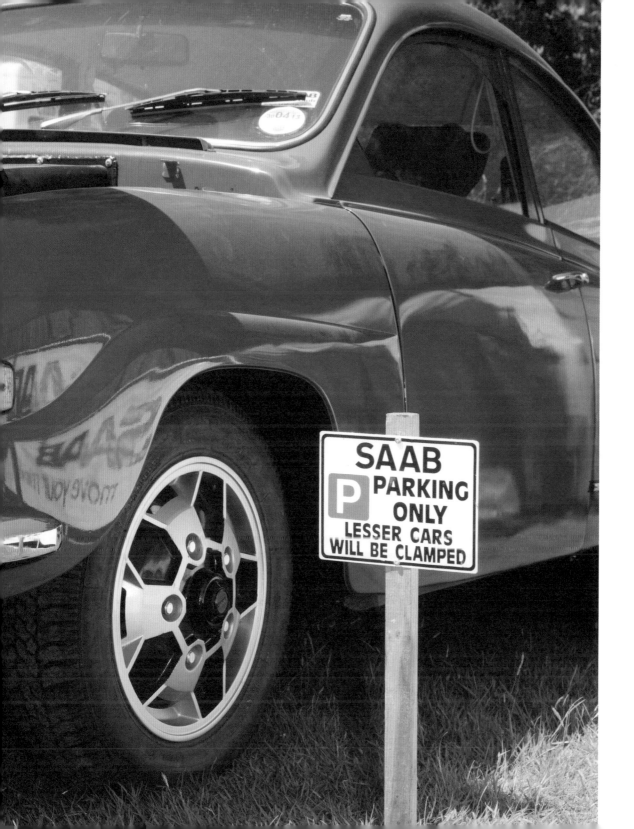

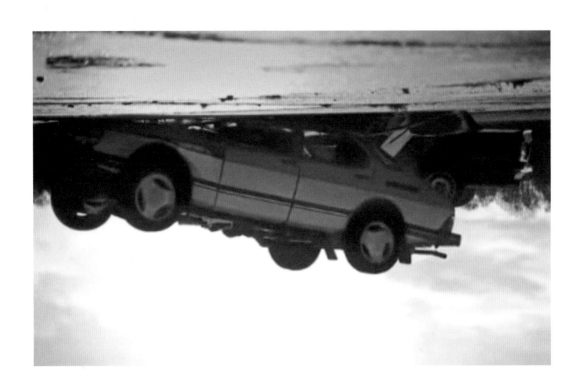

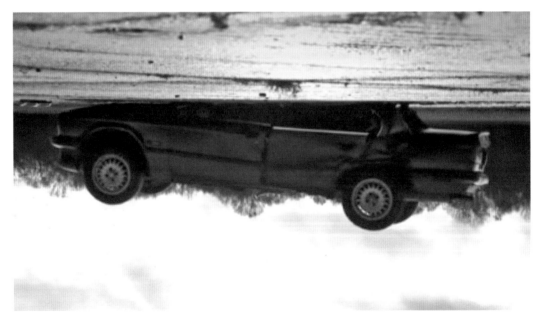

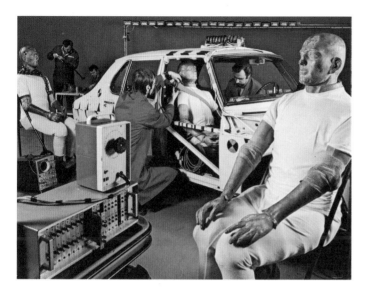

Opposite: A Saab and a
BMW being dropped by
a crane (shown upside
down). Left: Scene from
a 1970s Saab manual.

11

BODY-BUILDING

Top Gear once showed what happened when a Saab 900 and a BMW 3
Series were dropped by a crane from an identical height, onto the roof.
I'm showing the pics upside down. You can then see what happened
more easily. Guess which is which.

Saab's first chief designer was Sixten Sason and all the models up to
the Saab 99 were his babies. But then he died suddenly aged only 55.
A terrific loss. His protégé, Björn Envall, took over. Björn would lengthen
the 99 front and back, and so was born the 900.

Above is a 99 being prepared for a head-on impact, an image not
usually included in car sales brochures. With Saab, it was.

12

HOLD THAT ROAD

One of the outstanding characteristics of a Saab is that it goes where you point it. This was first noticed when Erik Carlsson got behind the wheel of his Saab. It was not at all powerful as rally cars go – two-stroke and three cylinders. It must have been more like riding a motor bike. But, like a motor bike, it sure could hold the road. And holding the road won rallies.

When I was in the USA we would have heavy snow where I lived. But I had a front-wheel drive Saab 900. It stuck to the road as well as a four-wheel. I soon took that for granted.

Four years later, I moved back to England, first selling my Saab because I wouldn't get much for a left-hand drive over the pond. I bought a BMW 325i. So much smoother, especially through the gears. And, like the Saab, I soon took that for granted too.

I was now living in the middle of the lovely Shropshire countryside. Early one morning, I looked out of the window and saw thick snow everywhere. I hadn't seen any snow since returning. It certainly made Shropshire look even prettier. And I didn't give what lay ahead a second thought.

I had to attend an important meeting in Wolverhampton that morning. In fact, I would be chairing it.

My rear-wheel drive BMW was a bit slippery at first, but I kept it straight. Somehow. Eventually I reached a modest hill.

I would have chaired that meeting. Had I kept my Saab.

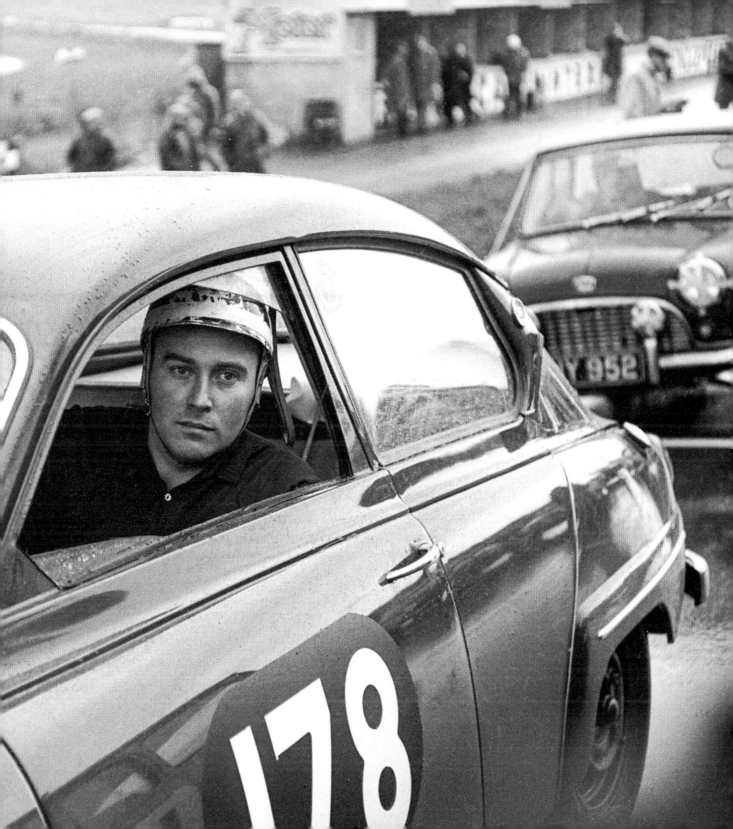

SAAB
900

980

1979 thru 1988
All models □ 2.0 liter (121.0 cu in)

Automotive Repair Manual

Terry Davey
© HAYNES

EVERY MANUAL BASED ON A COMPLETE TEARDOWN AND REBUILD

13

BREAKDOWN

When your old Saab just doesn't work – and this can happen, occasionally – one of the joys is the face of the breakdown person when they arrive. They light up.

'A Saab, eh? Great cars. Different. My boss had one when I was in the army.'

The breakdown person soon gets it going. You thank them.

'No problem. It's a temporary fix, but take it to a repair shop with some knowledge of these things and ask them to get that part. Or order one yourself, get out your Chilton or Haynes, and fit it. Not too difficult.'

You thank them again.

'You are most welcome, sir. Great car. Shame they stopped making 'em.'

There's a sense of responsibility, righteousness even, when you repair it yourself. Because you are now your Saab's earthly guardian, seeing as its parents are no longer around.

The Haynes Manual
for the Saab 900,
1979–88.

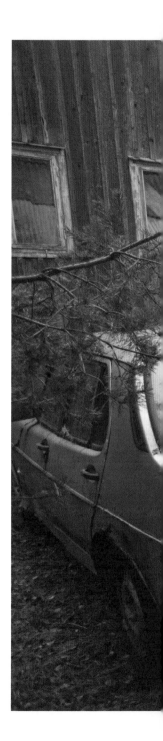

A Swedish car dump.

14

DEPRECIATION

Here we have a Swedish car dump. Saab and Volvo are fairly well represented.

Any well-known artist's paintings increase in value after they have died, as there will be no more to go around. Unfortunately, Saab's output did the opposite.

That is particularly the case with the post-GM cars. Which means it is still easy to pick up a respectable Saab 9-3 or 9-5, say, for the price of a new bedroom carpet.

Modern cars, and I include the post-GM models, do not rust, and have engines and gearboxes that keep going longer. But there is a bugbear. The electronics. These crucial bits may not be worth replacing when a car gets old. Not with a Saab. Get that part.

Luckily, because they don't have so many of these electronic bits, if any at all, the comparative value of pre-GM cars, such as the V4s, 99s and 900s, remains largely unaffected. In fact they have increased. Perhaps that is because some Saab snobs (luckily there are only a few of us) want a pure Saab car. Pre-GM.

The good news in all this is that as time passes since the last Saab was made, your car can only go up in value, whether it is pre- or post-GM. Because increasing rarity dictates price. So please look after it. I'm sure you will.

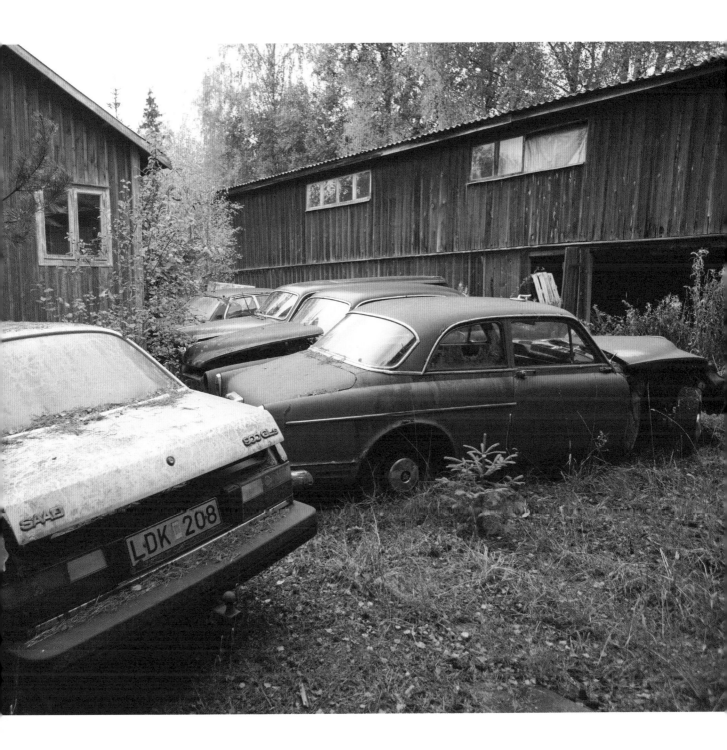

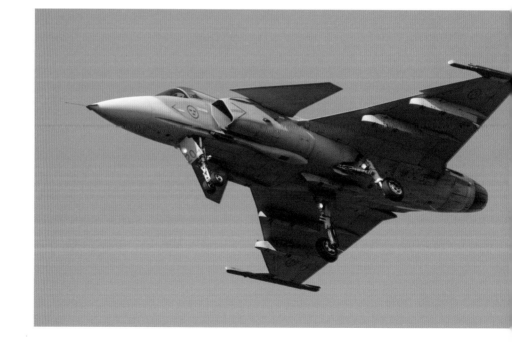

Above: The mythological
gripen on display at
the Saab factory in
Trollhättan.
Right: Saab JAS-39C
Gripen jet fighter.
Opposite: Saab 9-3
Gripen Edition 07 (1994).

15

WHO WANTS ROAR?

Some Saab bespoke models boast a very throaty roar that tells us they are there – in a sophisticated way, of course. This harks back to Saab's fighter plane pedigree. The car is a 1994 Saab Gripen Edition 07 with a gripen painted on its flanks, to make sure you know.

Which is the Saab Gripen here? The answer is both.

By the way, *gripen* is Swedish for griffin, a mythological creature with the foreparts of an eagle and the hindquarters of a lion. It is Saab's crest, derived from the family coat of arms of the Swedish aristocrat Count von Skane, founder of Vabis, a Saab forerunner.

The gripen was first used on Saab cars in 1984, acknowledging their arrival at the smart end of the market.

16

SAAB HOT AND COLD

Here is a bird's-eye view explaining the climate control in a Saab 9000.

The company put a huge amount of effort into getting a powerful heater and, later, as they began seriously exporting, equally powerful air-conditioning units for their cars.

Today it is taken for granted. For a North American summer, it is essential.

In the UK, with its mild summers and winters, it wasn't always thus. Not being essential, at first A/C was regarded as a status symbol, especially when it replaced that British favourite, the sliding sunroof, as the must-have accessory.

When I took delivery of a brand new Saab in New York City, back in the summer of 1984, I was astonished at the power of the air conditioning and, even though this was a Scandinavian import, the power of the heater during that Atlantic coast winter.

Saab always went strong on their cars' all-weather capabilities and, while their speed and safety were at the forefront, heating and cooling their customers effectively was regarded seriously.

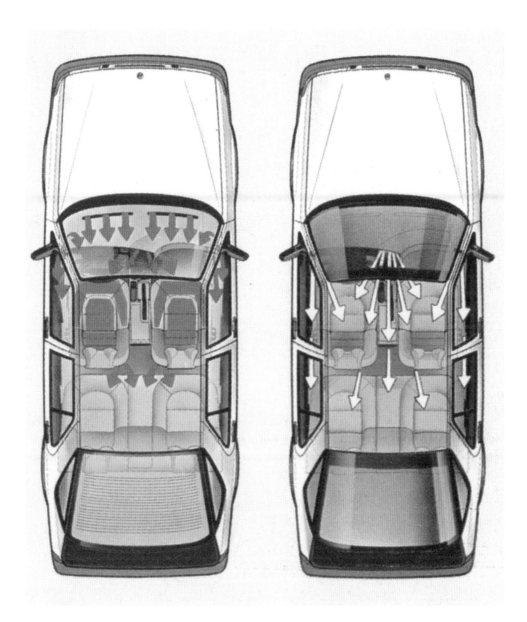

Auto and
stickshift Saabs.

17

AUTO OR STICKSHIFT?

Some Saab owners wouldn't dream of having an automatic. Not enough fun. Others think, 'Why not? I exercise at the gym already.'

Here are the options: stick or auto. The thing they have in common is the position of the ignition key. Saabs always had it just there to lock the gearbox, to make it difficult to steal the car. Actually, that's a myth. Look at pictures of early Saabs. The ignition is on the dashboard.

Saab's thinking was that this quirky positioning would also make the key less of a hazard in a road accident than if it was behind the steering wheel, where you could hit your knee. We must take Saab's word for this, because their crash testing was second to none.

As for car thieves, I'm not so sure. Would someone break into your car to waste time fumbling around trying to find where the ignition is, just like we do at the car rental (before figuring out it's got a start button)? They wouldn't get very far, because the gear box is locked when you remove the key. So it is easier to choose another brand to steal.

As for the stick or auto debate, all I can say is that a Saab auto is a lot easier to drive. In fact, their auto gearboxes are a pleasure. Having said that, we more extreme Saabists can be contrary. For us it has to be a manual shift. If you are not an extreme Saabist, steer clear, especially from a 900 Turbo manual, where making a gear change is an art. The clutch has to go right in every time. But when you let rip, the drive is exhilarating.

Why was Saab's five-speed box on the challenging side? That's because Saab had a four-speed standard transmission but didn't have enough money to develop a five. So they crammed another gear into the four-speed casing. By the way, the Saab 96 was one of the last European cars made with a column gear change.

18

TURBO? DEFINITELY!

I must confess I had no idea who Dickie Davies was when I saw this ad. Someone arty, I assumed, given the streaks in his hair and the reference to his 'studio', with enough talent and success to buy a Saab Turbo. I have since learned that he was the debonair presenter of the hugely popular *World of Sport*, a British TV show in the 1970s and 80s. This advertisement conflates the high performance of the car with the correspondingly high status of Dickie.

There had been turbos from other makes before. But it was only Saab who built their whole identity around this one model.

All a turbocharger does is force more air into the engine cylinders and compress it, which allows more fuel to be added. On the old Saab Turbos there was what was called turbo-lag, as the turbo spooled up. But a few seconds later, it kicked in and whoosh! The car shot forward.

The acceleration was astonishing for the time. Indeed, the 900 Turbo was labelled by some motoring correspondents as the 'poor man's Porsche', a back-handed compliment if ever there was one. But a compliment nonetheless.

HOW DICKIE DAVIES STREAKS AHEAD.

We're not sure whether it's his hairdresser, or just the distinguished feeling of driving a Saab that puts the streaks in Dickie Davies' hair. One thing we do know is that a man who drives a Saab Turbo doesn't need to worry about arriving late at the studio.

SAAB

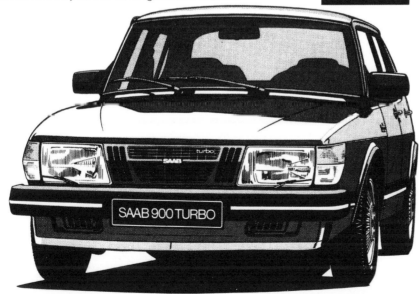

SAAB 900 TURBO

Saab (Gt Britain) Ltd. Saab House, Fieldhouse Lane, Marlow, Bucks. SL7 1LY Telephone: Marlow (062 84) 6977.

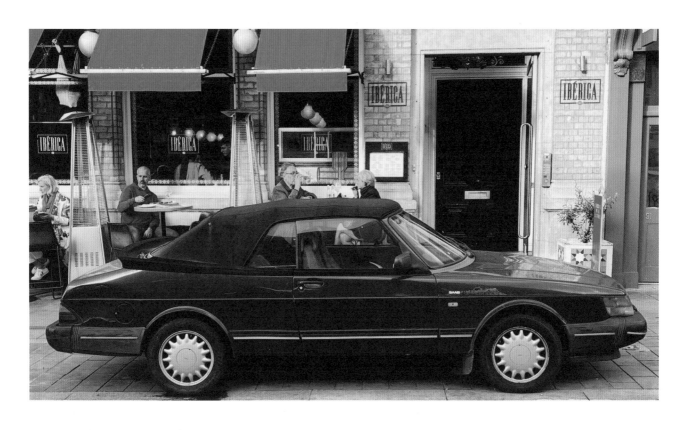

19

WHICH COLOUR?

Today there is a bewildering array of colours to choose from when you go to order a new car. All in grey.

 'What about this grey?'

 'Ah yes, Night River. A very good choice, if I may say so?'

On and on it goes. Fifty shades of grey.

 Saab in its heyday was simpler. Black, white, yellow, red, silver. Blue, occasionally (dark or light). Dark green. And a curious green called Opal. There is one of those somewhere in this book. And a sort of diarrhoea, but we will forget about that one.

 Here are five 900s from a time when Saab was at the top of its game. Which colour do you prefer?

Saab 900s in green, black and silver.

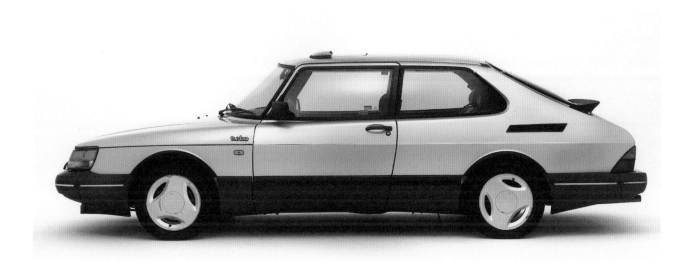

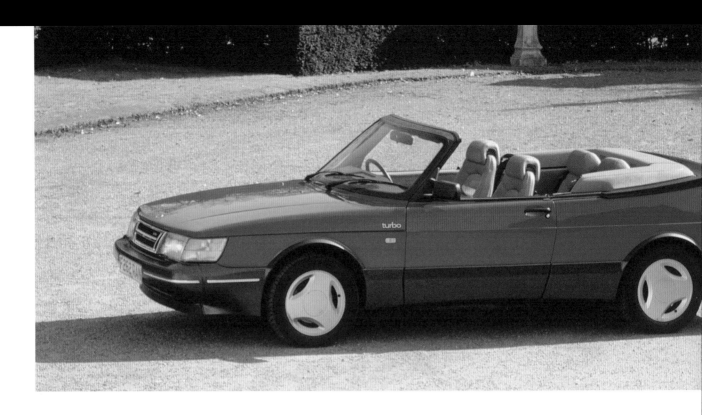

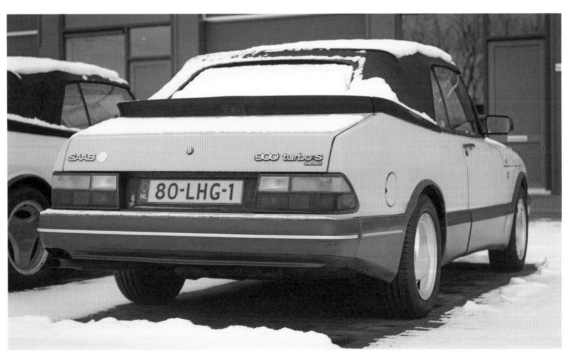

Saab 900s in red and yellow.

Yellow and red are the eyecatchers. These were the favourite for commercials and pop videos. The yellow looked best in the snow, while the red was right for Southern California or the French Riviera, in which case the cabriolet version was obligatory.

The silver, like the white, was the most understated. I've had both and I still own a silver.

The black meant power. When this pulled into your office car lot, someone was either for promotion or being let go.

The dark green was the coolest, such as the elderly, battered beauty on page 50, regularly parked outside a restaurant in hip Clerkenwell, London.

And there were two in grey – dark or light. Saab was sexy long before *Fifty Shades*.

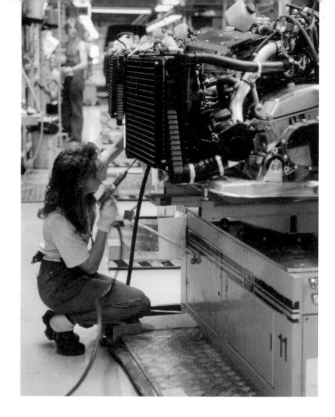

20

SAAB HIS AND HERS

Saab's ethic, unlike many marques, has always been pretty gender-balanced.

This goes back a long way. Saab employed more women as a percentage of their workforce than other car manufacturers. Here is one working with engines on automated trolleys at the Trollhättan plant.

The other pics are from a 1964 sales brochure for a Saab 96.

Saabs were also known to be driven by the most courteous motorists. Perhaps because many were women.

Actually, all Saab owners are courteous and friendly.

Above: Worker at the Saab factory at Trollhättan. Opposite: Images from the Saab 96 sales brochure, 1964.

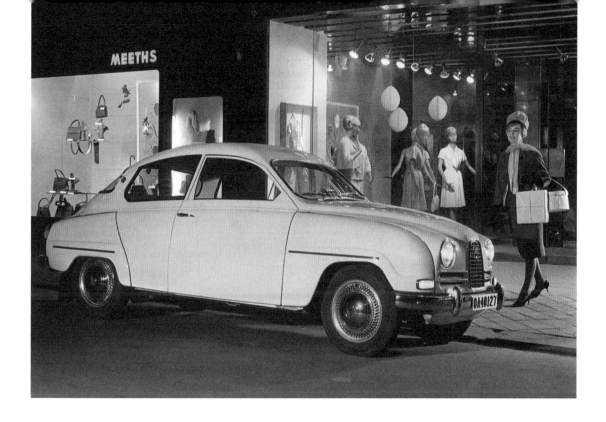

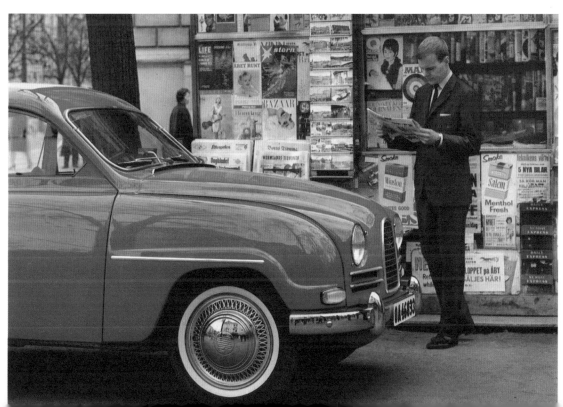

Saab mousemat
by Skandix.de.

21

PARTS ... ANYWHERE?

When you buy a defunct make of car, the worry at the back of your mind is always, where you will get spares when your car needs them? Which it will, as do all cars.

The first answer is an autocycling yard, and it doesn't take long to find what you want cruising Google and eBay.

But these are used parts. They may work, but for how long? If you're looking for new parts, then a good place to start looking in the USA is saabparts.com, while in Europe there is Skandix. Your first new part should be a Saab mousepad with a picture of the very first Saab looking a little mouse-like.

But seriously, join the Saab Club of North America or the Saab Owners Club of Great Britain. In Sweden it's the Svenska Saabklubben.

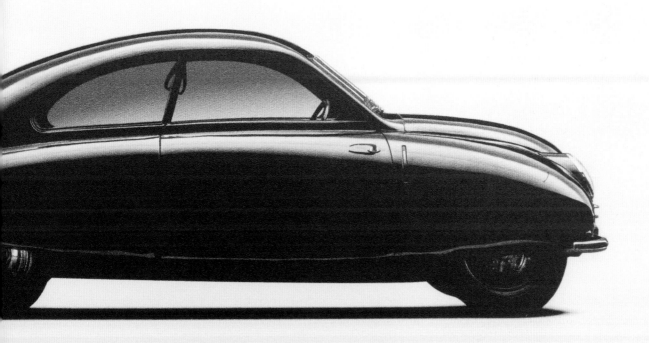

Saab
Original

www.saabparts.com

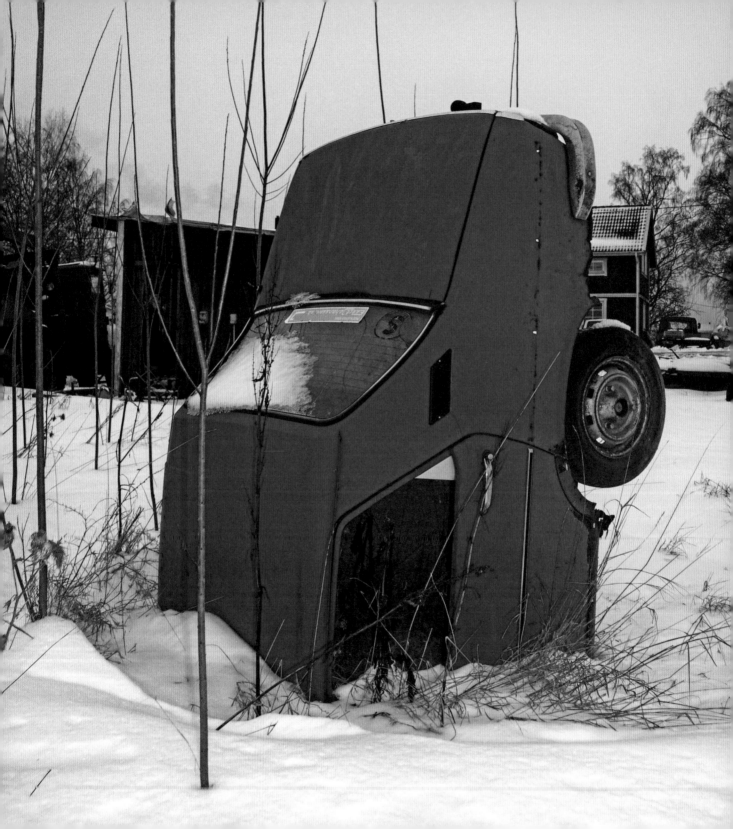

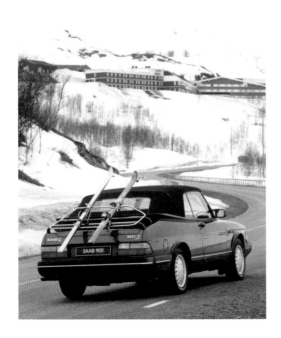

22

SNOW + SKI = SAAB

'Is a ski-rack a characteristic accessory on a Saab?' you may ask. Silly question. Of course it is. In fact, it is an essential accessory if you are image-obsessed.

Can you imagine a Saab in a ski-resort area without one? Or indeed anywhere in the winter, except the desert.

In fact, whatever happened to ski-resort visiting by car when Saab left the scene? A Saab was de rigueur from the Rockies to Switzerland. With another make of car, just look what could happen.

23

I LEFT IT IN THE CAR ...

What would you expect to see on the back seat of a Saab? Something highbrow? Something sporty? Something left-field? How about a book about Proust, a tennis racquet and a copy of the *New York Review of Books* or the *London Review of Books* – with its back cover showing as it is here.

 All to be seen, understood and respected, especially when you have watched the award-winning Japanese film *Drive My Car*.

A typical Saab
owner's backseat.

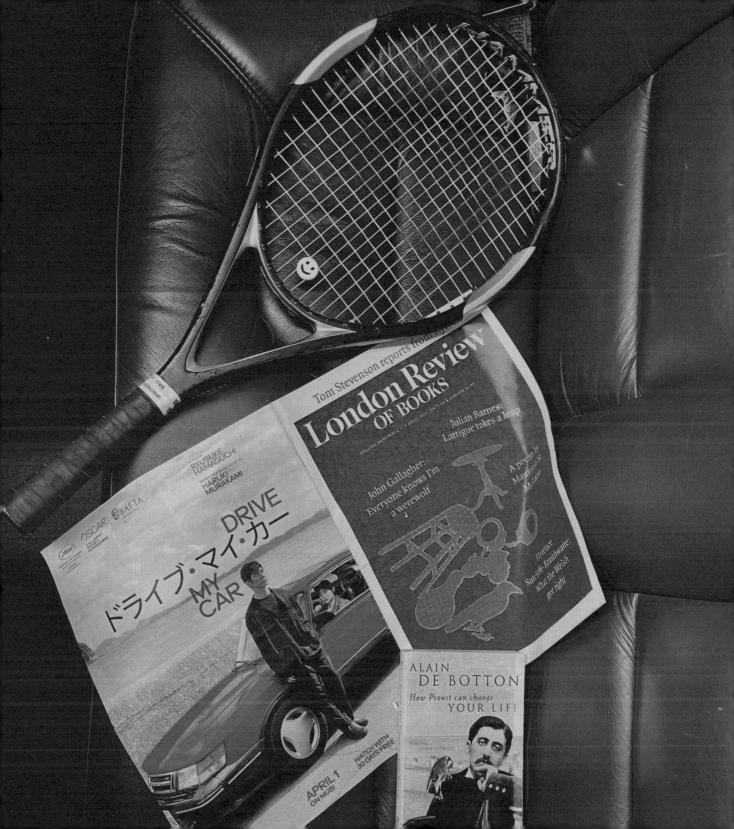

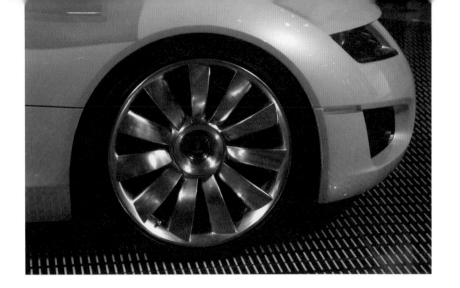

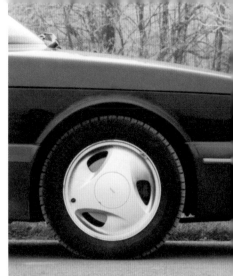

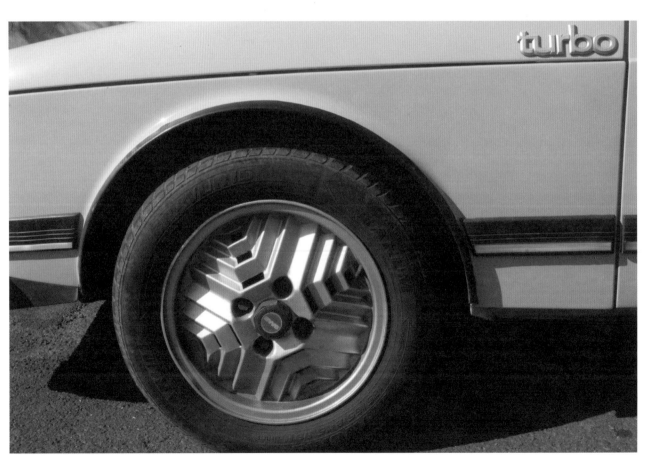

24

GREAT WHEELS!

Saab had an obsession with the wheels of its cars. Here are three examples: the Aztec Wheel on a taupe-coloured Turbo 900; then a regular Aero 92 on a black 900 Aero Cabriolet. And last, but not least, the Concept Wheel on a blue Aero X, itself a concept car.

Why did Saab have this obsession? Well, what was the first car Saab ever made?

Clue: see the introduction to this book.

Swedes are embarrassed if they don't do it right first time and that is because they usually do it right first time. But given a snafu, they can overcompensate.

By the way, I think the regular wheels look best. The others try a bit too hard. And appearing as though you are trying too hard is not really Saab. Or Swedish. And that's because both brands are cool anyway.

Clockwise from above left: The Aero X; the 900 Aero Cabriolet; the Turbo 900.

An Ursaab in a wind tunnel.

25

ALL-WEATHER STABILITY

From their beginning, Saab revolutionized the testing of a car's stability, simply because they applied the technology of their airplane research, such as a test for lift. This picture shows a Ursaab being assessed in 1947.

You would assume, quite understandably, that a wind tunnel just tests the wind on the front, the back, the sides, the top and underneath the car, and in this way the car's aerodynamic capabilities are developed and fine-tuned.

Saab also used theirs for temperature fluctuations and for extreme weather conditions – sandstorms, monsoon rain, sleet and snow (okay, they forgot the road-ice jamming up their first car's covered wheels). They also made sure the interior could cope with very extreme weather, and that is why the Saab's heating and air conditioning are hurricane force.

Saab took a holistic view in creating their cars' legendary stability and usability in all weathers – a leading consideration for Saab buyers.

Did the idea of using the wind tunnel for everything come about because Saab couldn't afford separate facilities for each weather condition? More likely, it was because that was how their airplanes were assessed, and they simply continued the tradition.

No other manufacturer took this approach from its very beginnings, other than Britain's Bristol Cars. That's because they were an offspring of the Bristol Aeroplane Company.

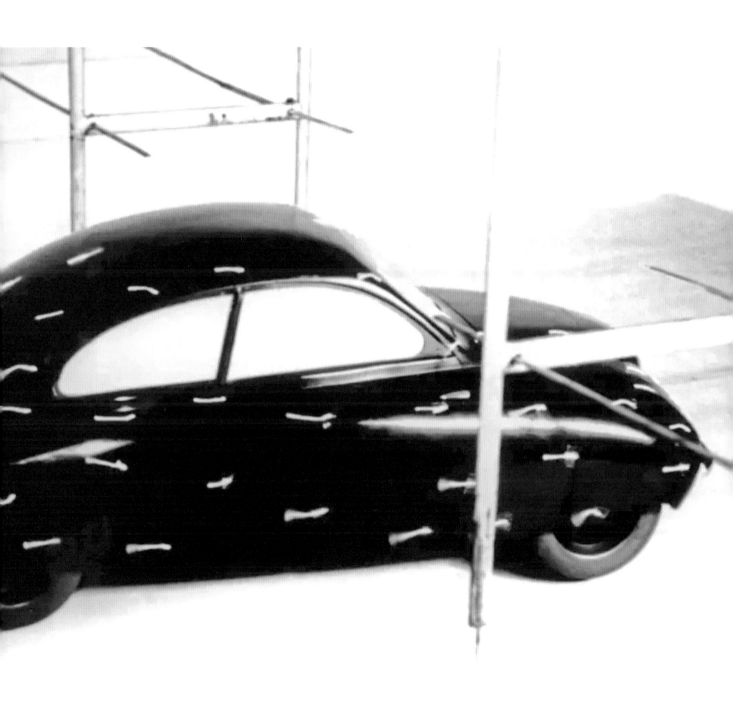

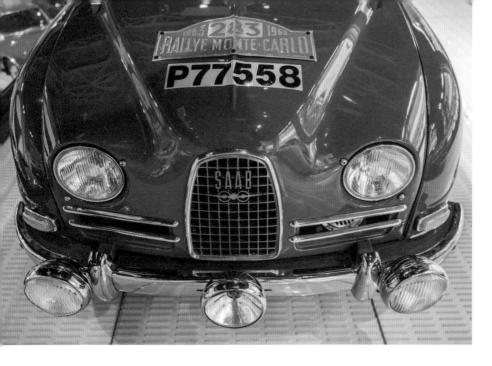
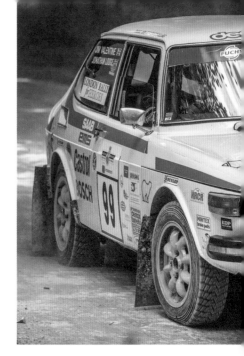
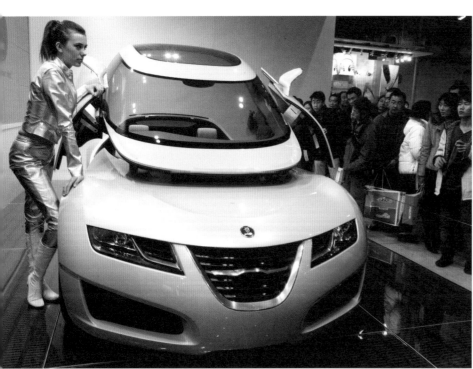

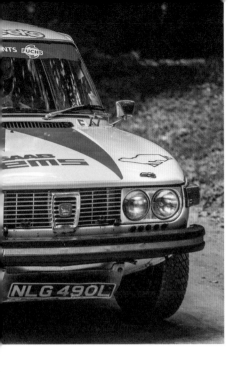

26

FRONT

The lovely Rallye Monte Carlo Saab 96 has a distinctive look.

The year before Saab's merger with Scania, the new 99 emerged. Notice how an adaptation of the almost square early Saab radiator hangs on as an emblem in itself, now set in the centre of the 99's grille.

The frontal look of a Saab was established by the introduction of the 900's use of a double strip as seen on this red cabriolet.

The double strip then went through many derivations, ending with the proposed Aero X of 2006.

Clockwise from top left: Saab 96 Monte Carlo Rallye Car; 1972 Saab 99 rally car; Saab 900 convertible; Aero X concept car.

27

SIDE

Of all the design cues that identify a Saab, it is the side silhouette that takes first place. There is something elegant yet practical about a Saab from this viewpoint – the lack of decoration and the sleek, wind-tunnel-developed profile that can be traced back to the Ursaab and the marque's airplane heritage.

This V4 looks purposeful as it charges through the Swedish countryside. I've chosen a wide, contextual shot because that is when you can appreciate fully the Saab's side profile – so distinctive in comparison to most other makes, new or old.

The 2009 9-3 Vector Sport Cabriolet is striking, with its characteristically Saab sloped and rounded windshield. Reducing wind resistance remained a principal obsession for Saab throughout the company's existence. And the aerodynamic windshield was unlike any other car.

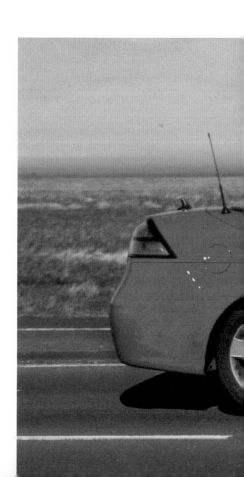

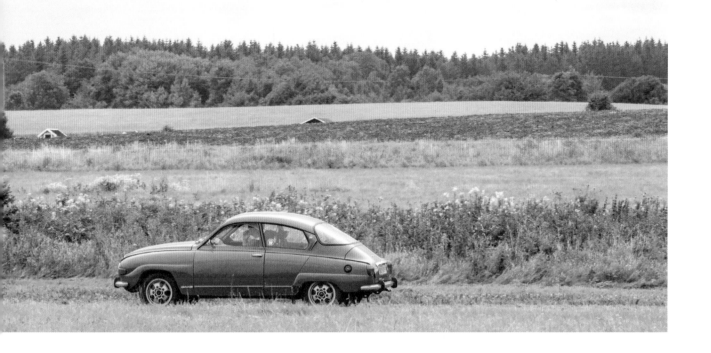

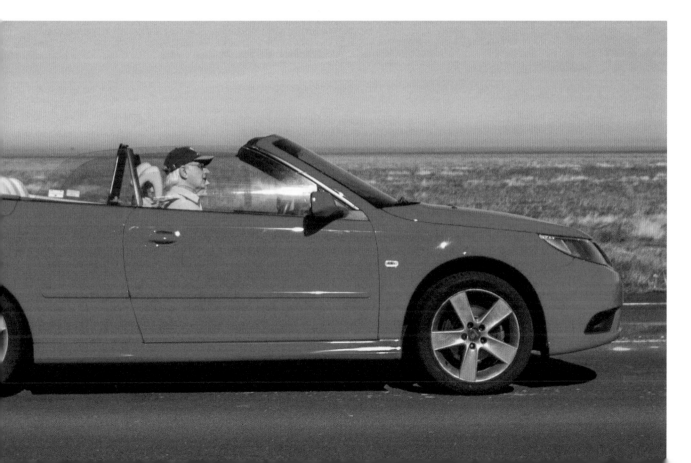

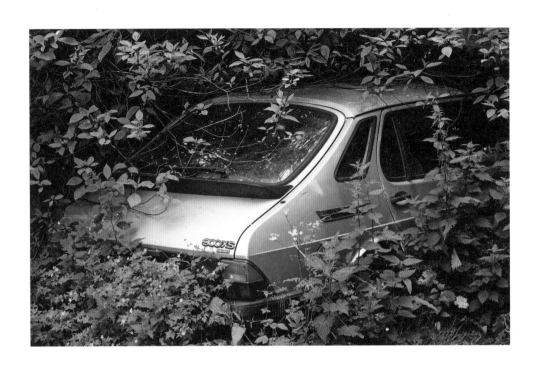

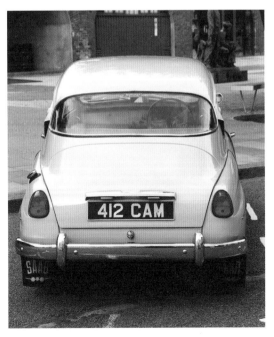

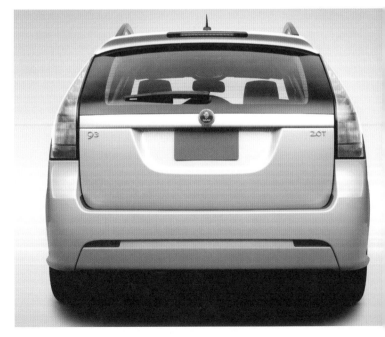

Opposite, clockwise
from top: A 900 XS
in a bush; the 2008
9-3; a 1962 Saab 96.

28

REAR

The rear end of a Saab has a special fascination. Not for Saab the square style of arch-rivals Volvo. Saab swoops were always plentiful, as seen here on this Saab 96 (below right) and on the abandoned 900 XS looking not unlike the tiger peeping through the foliage at the viewer in the Henri Rousseau painting.

Part of the swooping was the Saab's rear window. There was always lots of glass because a Saab was designed to provide its driver with maximum visibility.

The subtle spoiler was designed to keep the back end down effectively, but in any case, this model Saab looked better with it than without.

Some squaring off came with the introduction of Saab's Combi cars. They arrived quite late in the Saab story as a response to a fashion for sports station wagons, led largely by German rivals. The 2008 9-3 (below right) was elegant in its way, but not particularly Saab. It was probably GM who insisted that Saab go head-to-head with the fashions of the time.

Whether a Saab station wagon should be an essential part of their line-up is debatable. After all, their hatchbacks had provided tons of space.

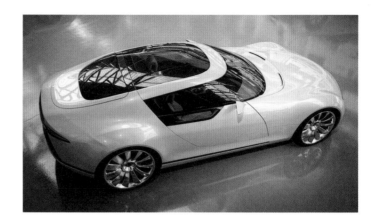

29

TOP

Seen from above, a Saab displays its greatest differences from mainstream cars. Here you can fully appreciate a Saab's aerodynamic elegance.

This 2009 9-3 Vector shows its wrap-around windshield to full effect, but what is also interesting is the curve of the car's front, which echoes the windshield's curve. This makes most other cars look boxy.

Michael Mauer, its chief designer, was inspired by a Saab airplane. The curve not only helped aerodynamics and visibility but also reduced reflections. The dashboard was then subtly curved towards the driver so everything was in easy reach.

The other image is of an Aero X in 2006. Saab were way ahead with this concept car, which also boasted other advanced features, and it is a tragedy this vehicle never reached production.

The Aero X windshield was as curved-extreme as Saab was ever to get. But then Saab never went in for a straight line when a curved one would do.

Above: The 2006 Aero X. Opposite: The 2009 9-3 Vector.

30

THE SAAB EMBLEM

Saab's emblem went through many iterations.

There is a story that only one person, in a whole team of car designers working on Saab's Ursaab prototype, held a driving licence. They were airplane designers, and you would have thought that the motif of an airplane would have found its way into the emblem of a car unlike any other. Not so. A nondescript ']['92' emblem on an equally nondescript shield was chosen.

But then, a nod to Saab's aerospace heritage appeared. The first production car, the 1949 Saab 92, had a shield with 'SAAB' written on it, to which extending wings were added. This image was not entirely obvious, so the next iteration showed the Saab name with a silhouette of a twin-engined plane flying straight at you, as used by the airplane division itself.

The early 70s saw the plane retained on the rare Sonett, as seen on the yellow car here. But it was dropped from the V4 and, instead,

Saab badges through the years.

'SAAB' appeared in joined-up capitals. With some occasional minor adjustments, the emblematic 'SAAB' lettering would be retained by the car company for the rest of its life.

This lettering, together with the griffin head, taken from the coat of arms of Skane in the southern Swedish province of the same name, is the emblem we remember most, although it changed again in the mid-1980s when Scania bought into the company and their name was added. It later disappeared when Scania parted company, leaving the Saab name once more proudly alone.

GM later offered an entirely GM-engineered SUV, with the Saab emblem stuck on a version pitched somewhere between their Chevy and Cadillac. This was badge engineering at its most blatant, and about as far as you could get from Saab's beginnings, a time when design engineering was central and the emblem a mere afterthought.

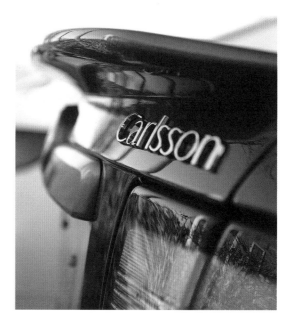

Saab special
edition badqes.

31

THE 'SAAB' SPECIAL-EDITION BADGES

Saab made many great cars, but it is the special-edition models that carry a special badge and, with it, extra prestige.

For example, to remind prospective buyers of Saab's success in the Rallye Monte Carlo, a sports version was launched with the 'Monte Carlo' badge added.

The Airflow was the logo of Saab's Special Performance Group (SPG). It produced cars for go-faster types and, like many of Saab's products, was aimed at the USA. This was Saab's most lucrative market, even though cars in America at the time were limited to 55mph. Paradoxically, this was probably why Saabs with kerbside go-faster logos sold well.

The Carlsson editions were named for Saab's most famous rally driver. Not only was the Carlsson designed to go faster but it provided opportunities for an owner to explain to the curious all about the rallying history of the company.

The Viggen (Thunderbolt) was named after the Saab airplane. This was a high-powered 9-3 and was sold mostly in the USA, where buyers were offered two days' fast-driving tuition in Georgia alongside the opportunity to dine with Saab's US executives. Presumably the dining took place after the tuition.

32

THE RADIATOR

Unlike a Rolls-Royce, BMW or Mercedes, a Saab did not at first boast a radiator unmistakable from a mile off. Rolls had its stern Parthenon topped by the Spirit of Ecstasy, BMW had its double kidney, while Mercedes radiators came in various shapes and sizes, each of them somehow making the marque instantly recognizable. They also had the most famous and oldest car emblem in the world.

Saab started with rounded-off squares, but established its distinctive look from the 900 onwards, as the 9-3 and 9-5 radiators show.

Below left: Saab 96.
Below right: Saab 95.
Opposite, above: 2008
Saab 9-3 2.0T.
Opposite, below: 2008
Saab 9-5 2.3T.

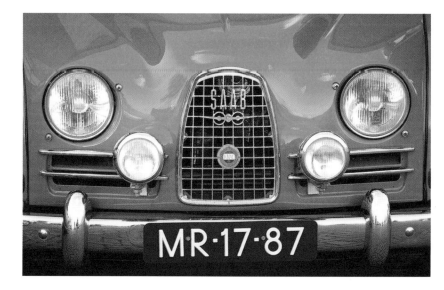

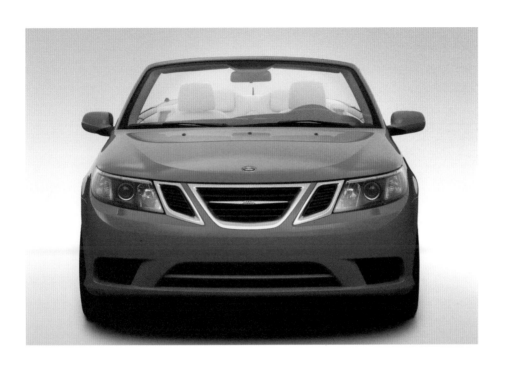

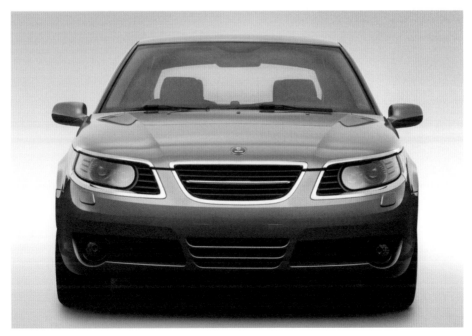

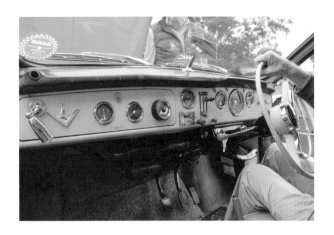

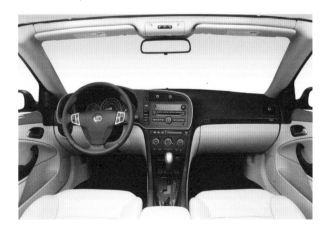

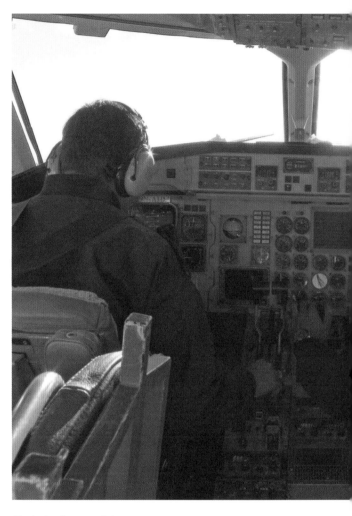

Clockwise from top left:
Saab 96 V4; Saab 340B
plane cockpit; 2008
Saab 9-3 2.0T; 900
Turbo Cabriolet.

33

THE DASHBOARD

The dashboards of early Saabs were designed very much as you would expect of a European car from the 1950s and 60s.

The Saab 96 V4 here (opposite, top left) is uncluttered, and the simple controls available at the time, of which there are few, are at an arm's length.

The future emphasis on a Saab cockpit being informed by that of their airplane is just not there. Perhaps the only similarity are the dials, placed on the glove box, and away from the direct sight of the driver.

By the time of this early 1990s 900 (opposite, centre), the airplane pedigree had been pushed hard as a key Saab selling point. All the controls are within easy reach. You were supposed to reach them intuitively without taking your eyes off the road, for which purpose the radio, for example, is purposely placed high. This Saab characteristic was here to stay, as seen in the 2008 9-3 (opposite, bottom left).

And, just for the record, here is the cockpit of a 340B airplane. All Saab again, except no reverse gear.

A characteristic that cannot be seen is the feel of a Saab's switches. They were positive and solid in feel. No soft touch for Saab, and instead just like a plane.

34

FLYING HIGH

Earlier in its history, Saab cars sold on their inventiveness, safety, reliability and romance. Romance meant reminding punters of a Saab's prowess in winning rallies, especially the Monte Carlo, which they did twice thanks to the skills and chutzpah of Erik Carlsson. He kept up the revs on his Saab's two-stroke, three-pot engine by not slowing down, explaining afterwards that he'd had no choice. A perfect case of necessity being the mother of invention.

But things changed after Saab took the decision to leave motor sport and to instead flaunt its airplane heritage.

It was felt that this had greater reach in the promotion of Saab to a more managerial middle class interested in combining comfortable, luxury motoring with excitement, but only when they felt like it.

A Saab advert
from 2006.

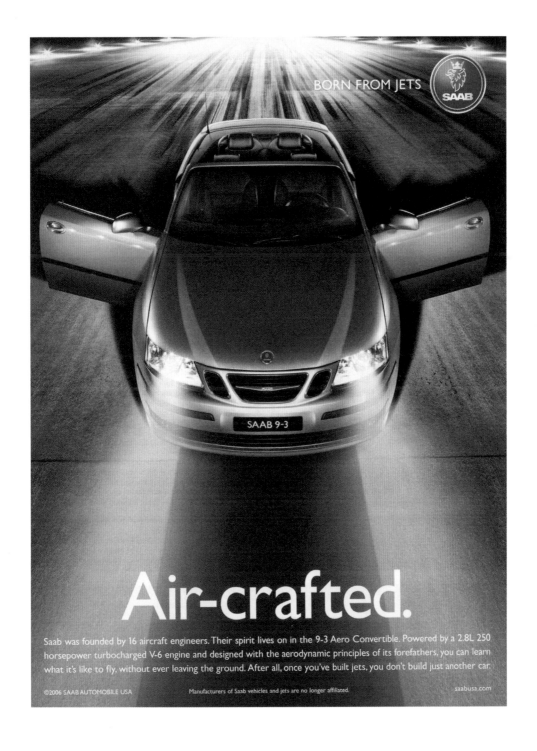

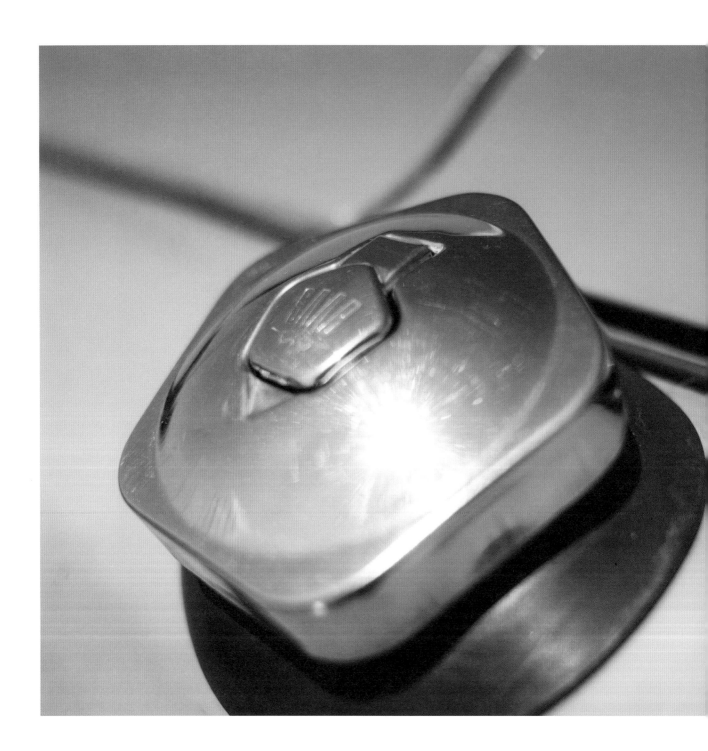

35

FUEL CAP COOL

Why put a photo of a fuel cap in a book like this? What is there to say about it?

Well, I would say it is rather elegant. It is from a 1962 Saab 96 and includes the Saab logo and a flip-up lock. The shape means it is easy to unscrew but very safe. This design would not have been out of place on a light aircraft.

But, more importantly, the design represents Saab's thoughtful attention to detail.

Airplane manufacturers don't usually go fishing in parts bins, but if you are a small manufacturer of cars you do. My Bristol 411, for example, was also made by a plane manufacturer, except its door handles were from an Austin Maxi and its rear lights a Hillman Hunter.

Not Saab. This fuel cap may have been made by WASO, who supplied other brands too, but Saab insisted their logo went on the key cover. When GM took over, this was increasingly a point of contention, as the cost of unique detailing was expensive.

But I love Saab for thinking about the look of something as basic as this fuel cap. Sweet. And important.

36

WHIPLASH CRACKED

Cars already had 'headrests' – a misnomer perhaps, because do you ever rest your head on one? – that were integrated, adjustable or adjustable automatically.

But Saab came up with the first active head restraint, which they dubbed the SAHR – the Saab Active Head Restraint. What Saab invented was a head restraint that improved itself in relation to where your head and neck happened to be, during an actual impact.

This had a phenomenal effect on reducing whiplash in drivers and their passengers, as well as fraudulent whiplash claims if a Saab was involved.

37

HOT BOTTOM

Heated front seats were first used in a Cadillac in 1966 as an optional extra. Saab, however, was the first car manufacturer in the world to make them a standard feature in their 99 model. From then onwards, heated seats as standard were to be found in all 900s and 9000s.

If there was one item that signalled Saab's decision to move into the luxury car market, it was probably the introduction of heated seats. The move was thoughtful, as it made punters recognize the Saab brand as upmarket, but on the downside it placed the company in direct competition with the money muscle of Audi, BMW and Mercedes.

Naturally, it was not too long before these marques also provided heated seats as standard. Saab had arrived, but into a tough market.

You cannot see a heated seat, but here is a picture of a couple of heated seats anyway. The other photograph is of a heated seat in a Saab Gripen fighter. Audi, BMW and Mercedes couldn't match that, because it was also an ejector seat.

Opposite, above:
Heated seat in a Saab
Gripen fighter jet.
Opposite, below:
Heated seat in a 2007
Saab 9-3 Aero.

38

SAAB ENGINES

Saab used several engines in their history, ranging from the two-stroke, to the V4, used in a Ford Taunus, through to a prototype V8 in the 1980s. The latter never reached production, thanks to Per Gillbrand, Saab's turbo supremo. Even though Bob Sinclair, Saab's US chief, had lobbied heavily for it, Per felt it totally un-Saab and that was that. Yet from 1989 a General Motors V6 found its way into some models.

But what moved Saab upmarket most in its key US market, away from its two-strokes and V4s, was the introduction of the Saab 99 and its offspring, the Saab 900. This was where an in-line, slant-four engine was first used, and it would become Saab's signature powerplant.

In the early 1960s Saab started researching a four-cylinder engine for its planned 99 model. They consulted Ricardo, a British engineering company. Ricardo knew that Triumph in England was working on a similar project and they recommended a meeting. Saab, never a company with a lot of cash to splash, was interested. With design input from Ricardo, the result was Triumph supplying Saab with their new slant-four engine.

It wasn't long before Saab started playing with Triumph's slant-four, with a redesign of the transaxle so that its case could be used as the oil sump. Saab then turned the whole engine back to front, putting the drive shaft and transmission further back, with the sump underneath. If ever there was one, here was a literal piece of reverse engineering. Why did Saab do this? In two words: weight distribution. A nose-heavy 99 simply would not do, because for Saab, limpet-like road-holding was their calling card.

In 1972, Saab started making the engine themselves. They completely redesigned the original engine, which by now had increased in capacity from 1709cc to 1895cc. Saab called it their B engine. In 1981 the B was developed into the H, with 1985cc. The H met California's new emission

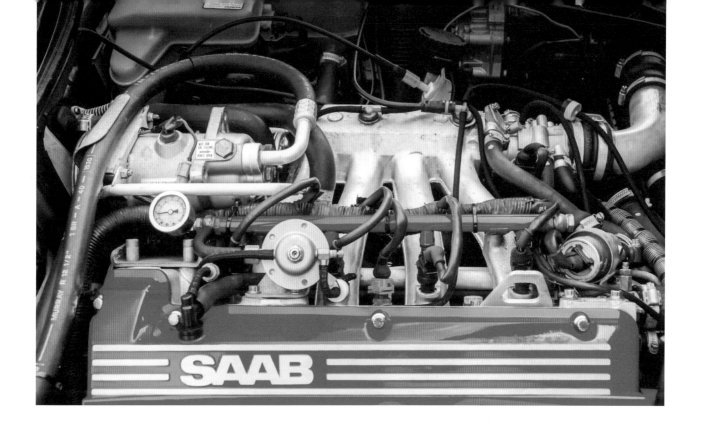

regulations, without the need to add a catalytic convertor. It helped boost Saab sales in the single most important automobile market in the world. Much more development of the engine followed over the years, such as a 16-valve, the addition of a turbo-charger and of APC or Automatic Performance Control to effectively manage the engine when it was linked with the turbo.

The idea for a turbo came about as a result of the Saab-Scania merger. Scania already fitted turbos to their trucks, but no one had thought of scaling one down to fit a regular passenger car. That piece of genius, first fitted to the 99 and then to the 900, helped promote Saab's name.

Saab's Slant-Four – slant because the four cylinders were inclined from the vertical – continued in development and production until 2010, with capacity increasing to 2,290cc and 185bhp in the 9000, 9-3 (OG-Viggen) and the NG 9-5, with some models offering 285 bhp.

Having this engine to focus on, forced Saab to think and act creatively and that meant that their slant-four would drive the spirit of Saab.

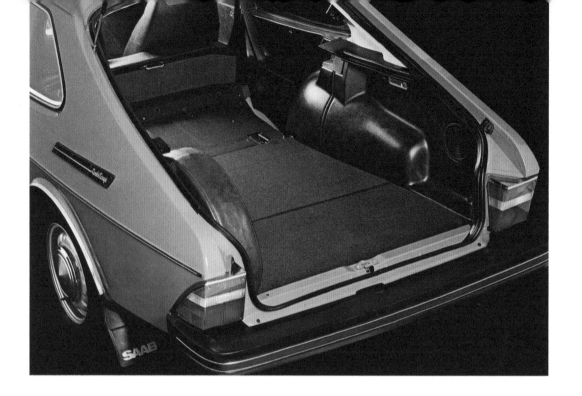

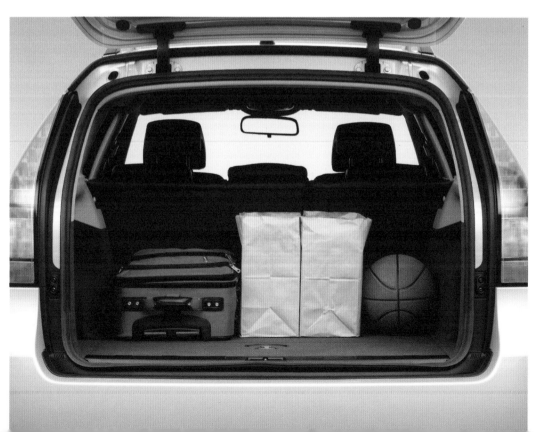

39

THE TRUNK (OR THE BOOT)

Before the arrival of the 99, Saab could only point to the 95 station wagon to remind us how much they could carry. But as beasts of burden the quantity would never be show-stopping because the Saab was a relatively small car.

From the 99 onwards, all that changed, because the trunk space now outclassed most similar-sized cars. The hatchback (Combi Coupé) with the back seats folded down was capacious. If you had to, you could sleep in relative comfort.

The 9-3 Sport Combi had even more room, rivalling Volvo, the estate car's European market leader in lugging stuff around.

Although increased carrying capacity was a good selling point, Saab were careful not to promote it to the detriment of their car's sportiness, lest they accidentally drove business to their Swedish competitor.

40

THE HOOD (OR THE BONNET)

Other than at the outset, with the first Saab prototype, the Ursaab, the hood of a Saab opened with the hinge at the front. If I was being mischievous, I could ask a young fuel-pump person to check the oil on my 900, allowing me to enjoy their voyage of discovery in trying to open the hood. Being a civilized Saabist, I naturally resisted the temptation.

Opening from the front was designed to give better access to the engine bay. And it was less likely to fly up when you were driving fast. These two points were important for Saab, until GM pointed out that front-located hinges required cantilevers. These were more expensive to make and fit, so from the 9000 onwards, hinges were moved back to the back. Thus was another Saab idiosyncrasy abandoned.

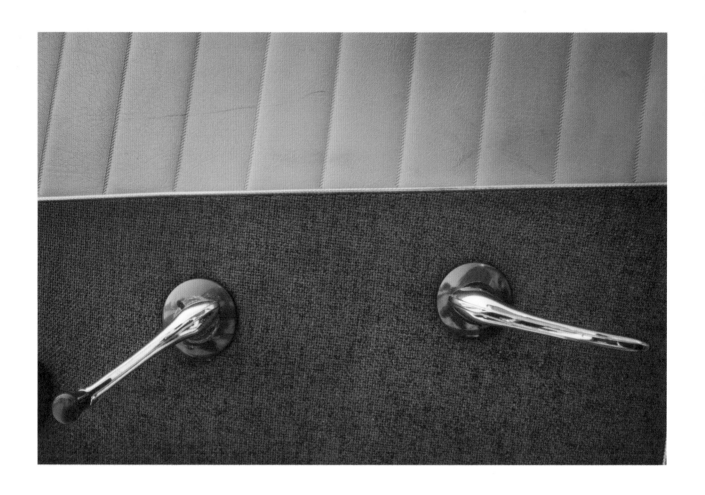

Above and opposite:
Interior and exterior
handles on a 1962
Saab 96.

41

HANDLES

I like door handles because they are one of the few parts of a car you have to, er, handle.

These handles are on a 1962 Saab 96 and, when you study them carefully, you realize how beautifully shaped they are. Would it be too extreme to say they are not unlike pieces of fine cutlery? I don't think so.

This extraordinary attention to detail is characteristic of Saab, a small manufacturer of mass-produced cars. They always insisted that what they made was first designed by them, or at least sourced and altered to fit their needs to such an extent that it became theirs.

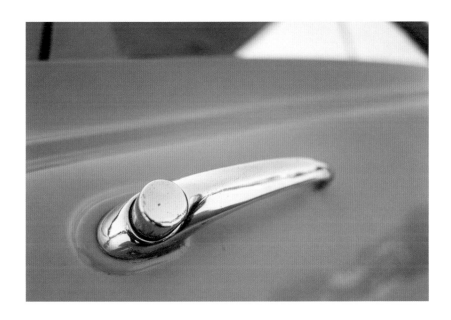

A splendid row of Saabs.

42

SAAB PERMUTATIONS

At first, Saab took a one-size-fits-all approach. You would expect that from a car manufacturer of Saab's size. So, they had very few models and permutations to choose from. And they were successful – the 96, 99, 900 and 9000 are cases in point.

It was, after all, unnecessary to offer too much choice, because anyone considering buying a Saab had made a niche choice anyway. Why provide a niche for a niche? It just didn't make economic sense.

Here is a good example of profligate permutations – a perfectly ordinary picture of the rear ends of late-model GM Saabs.

Think of the design, tooling costs and manufacture of these permutations. This is what you would expect from VW or Toyota, but even they, the largest manufacturers of cars in the world, were less design-profligate.

Little wonder that Saab struggled to turn a profit.

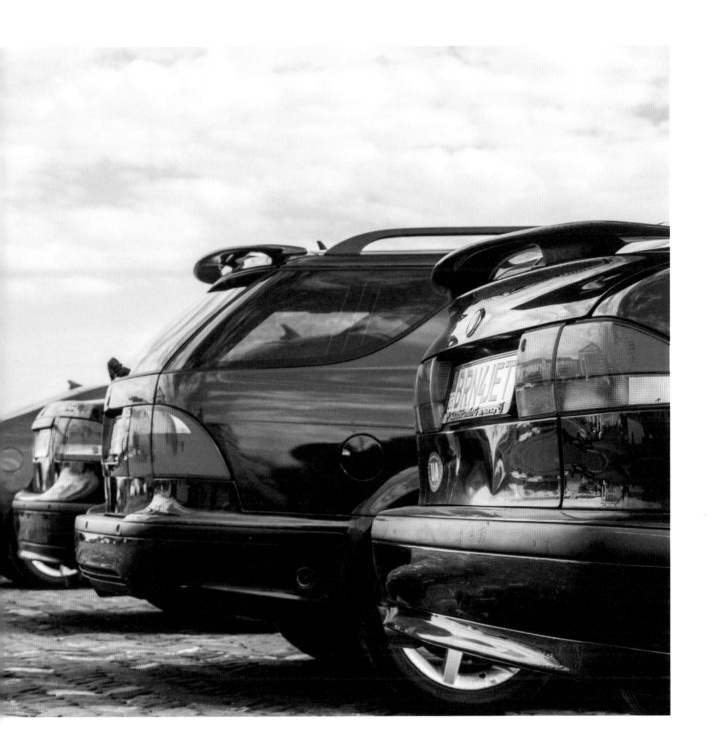

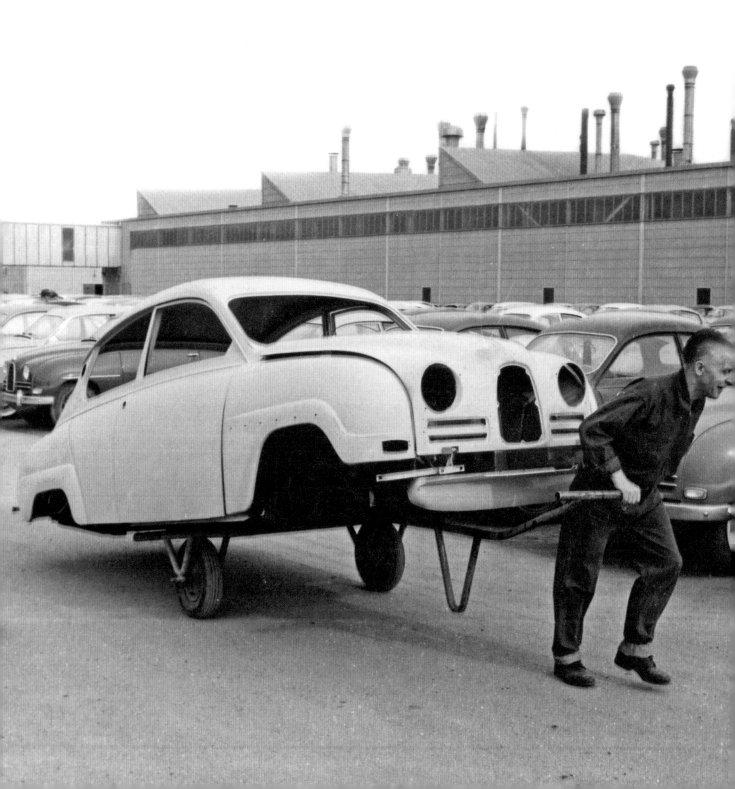

43

TROLLHÄTTAN

This photo of the man pulling a Saab body at the Trollhättan factory is intriguing. Was he the inspiration behind Saab's famous troll character? You could buy a troll sticker to put on the window of your Saab.

And here is Trollhättan after it had closed – my least-favourite photo in this book.

Opposite: Worker at the Trollhättan factory in Sweden, 1960s. Above right: Saab troll sticker. Right: The closed factory.

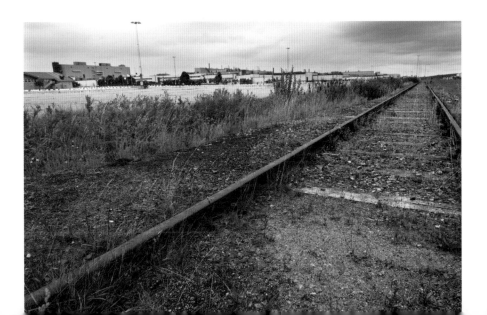

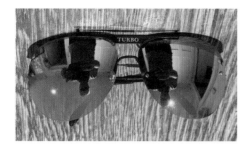

Left: My Turbo sunglasses.
Right: Wu Bai in *Time and Tide*, 2000.

44

TURBO SHADES

Sometimes a word catches on. It pops up everywhere, irrespective of its original meaning. And that word was Turbo, here applied to shades.

In the late 70s and early 80s, the Saab brand started to be seen as cool. You could now buy Turbo swimsuits, Turbo socks and Turbo shades, all to go with your Turbo Saab, whether you owned one or not.

Here is Wu Bai, a Taiwanese rock star, with a Turbo Saab. Is it actually a Turbo? It looks so, judging by the 'aeroskirts', although by the time this particular model was made, the magic Turbo name was displayed on the grille at the top right, which we cannot see, thanks to the man in the waistcoat. I still own an old pair of Turbo shades that I put on whenever I want to be taken back to the 1980s.

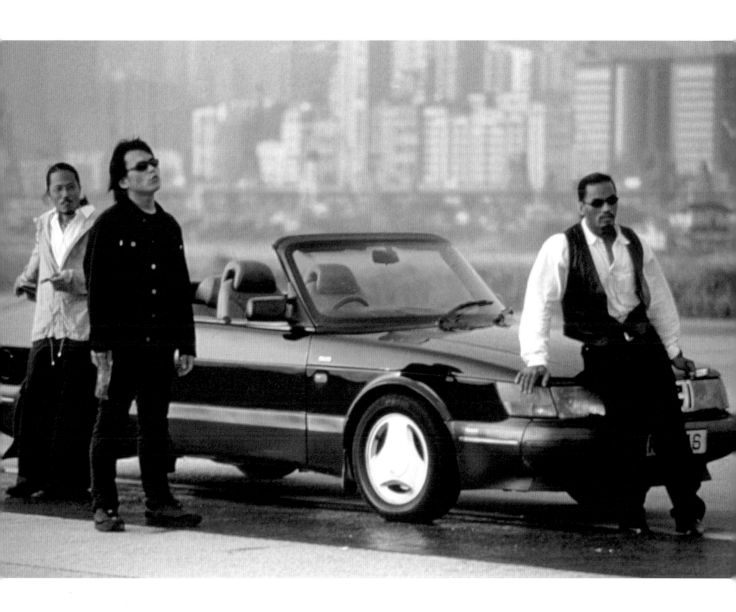

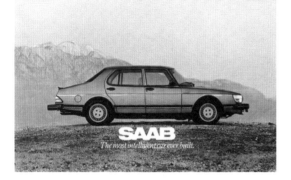
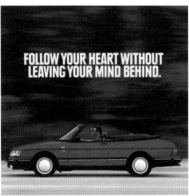

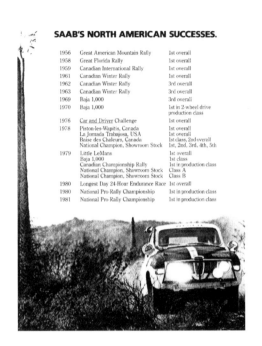

45

SAAB IN AMERICA

The one place to make or break Saab was America, because there were lots of creative types there aspiring to own a Saab, and with the money to do so.

At the end of the Second World War, Saab had a purchasing office in the US, originally set up to supply parts for airplane production, but that closed in 1952. Saab replaced it with its quirky marketing department – without doubt the company's most intelligent decision for selling the most intelligent car ever built, to those who were the most intelligent, of course.

Various US Saab ads.

46

RALLYING FOR SAAB

Saab attracted many rally drivers. Most were superb, not because they knew how to get the best out of a car but because they knew how to get the best out of a Saab.

The early rallying Saabs were small, with two-stroke, three-cylinder engines linked to a column gear change. It was a curious arrangement for any car, and you would not have thought it a first choice for a rallying one. Yet they held the road and Erik Carlsson kept the revs and speed up and drove to victory.

Erik Carlsson, Per Eklund and Stig Blomqvist were the three musketeers most associated with Saab, with Blomqvist's forename later possibly inspiring that of the anonymous racing driver in *Top Gear*.

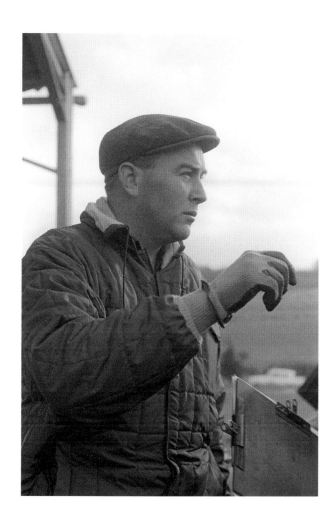
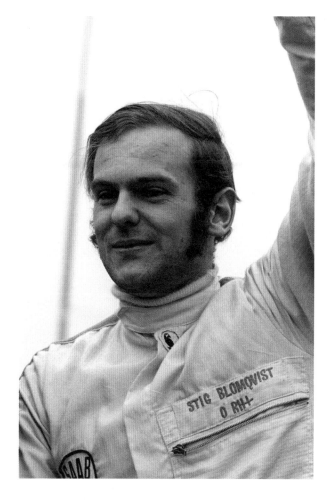

Above left: Erik Carlsson.
Above right: Stig Blomqvist.

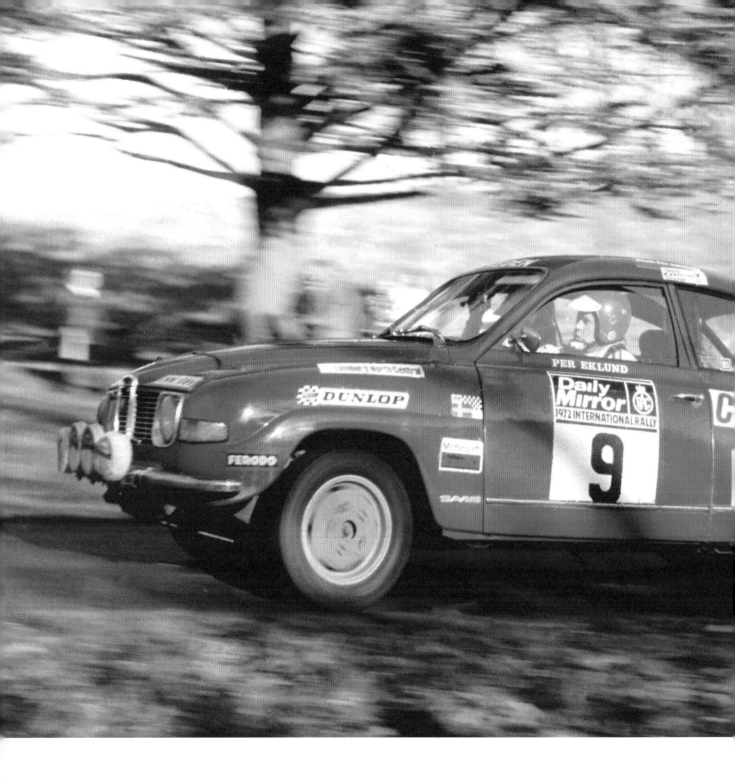

Per Eklund competing in
the RAC Rally, 1972.

Eklund kept going longer than the others in a Saab, driving a 900 Turbo in the 1997 World Rally Championship (actually that particular car was entered by Saab) and, nearly a decade later, a 9-3 in the FIA European Championship for Rallycross Drivers.

But it was Carlsson who became most associated with the marque. He actually was born in the home of Saab, and his wife Pat, a famous rallyist in her own right, was the sister of distinguished British racing driver Stirling Moss.

Carlsson won many international rallies, most famously the 1962 and 1963 Rallye Monte Carlo, driving a two-stroke Saab 96, thus beating much more powerful cars. And it was Carlsson who, years later, had a Saab production model named in his honour. Beat that. No wonder he was known as Mr Saab.

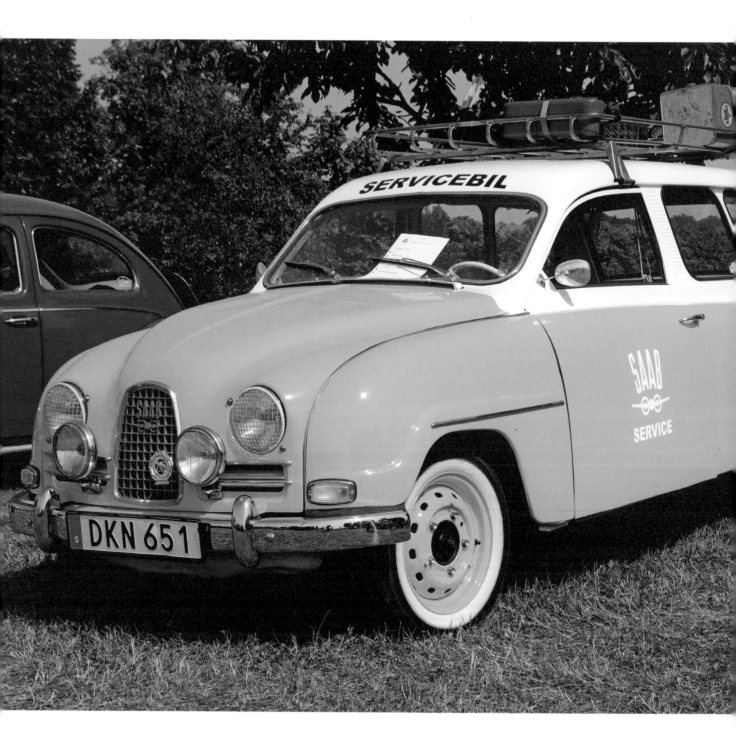

47

I LOVE THESE

I love these five Saabs. The 1964 95 in blue is a hoot. The 1975 99GL (page 112) is a pure Saab classic and in an unusual colour. The 1987 900 Cabriolet (page 113) is mine. I love getting behind its wheel, especially in summer. The 1970 96 V4 Rally car (pages 114–115) is simply the business. And I know – the red 2012 9-5 Sport Combi (pages 116–117) is a diesel. But this is a beautiful car, representing for me the Saab company's ending in style.

1964 Saab 95.

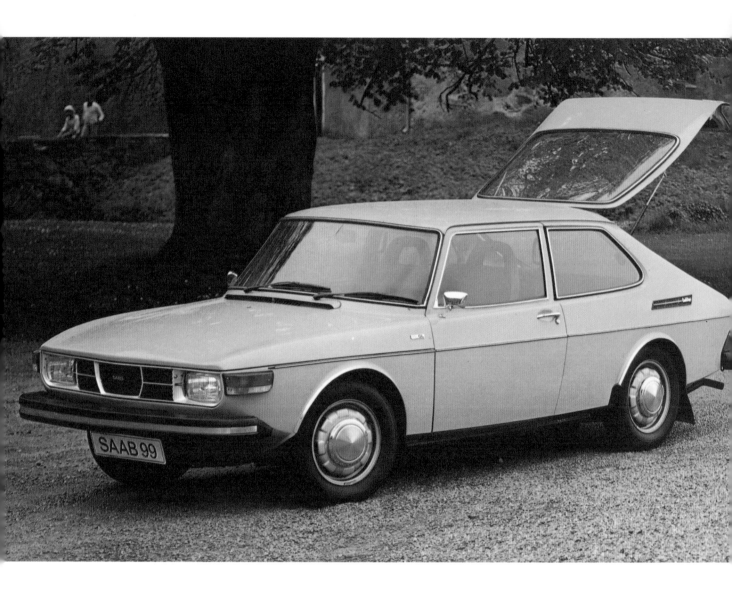

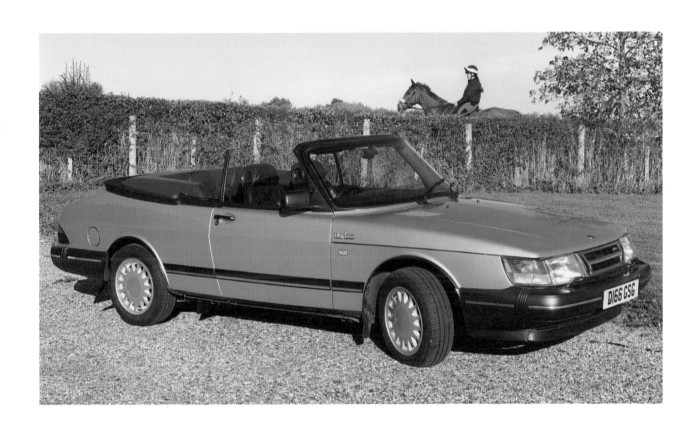

Opposite: Saab 99GL
Combi Coupé. Above:
My 1987 900 Cabriolet.
Following pages: 1970
96 V4 Rally.

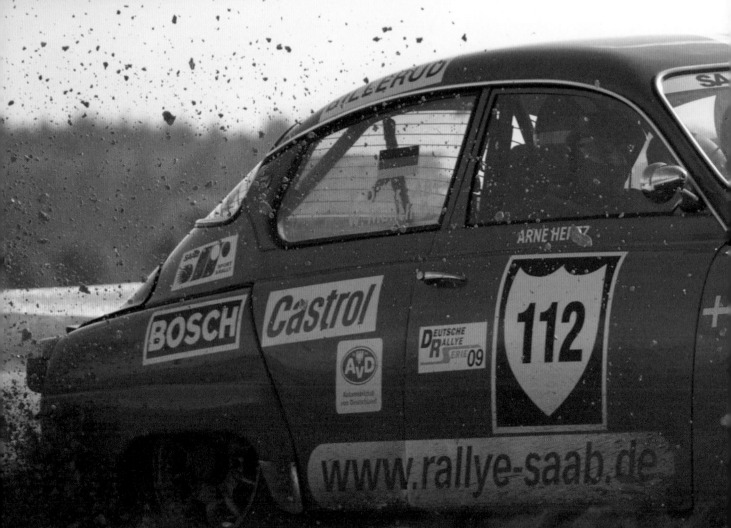

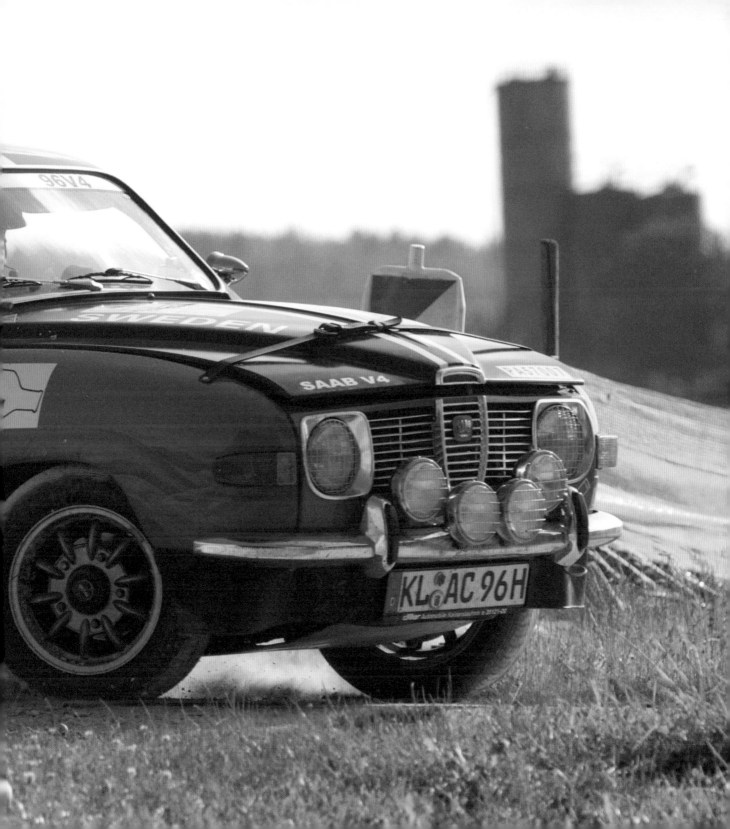

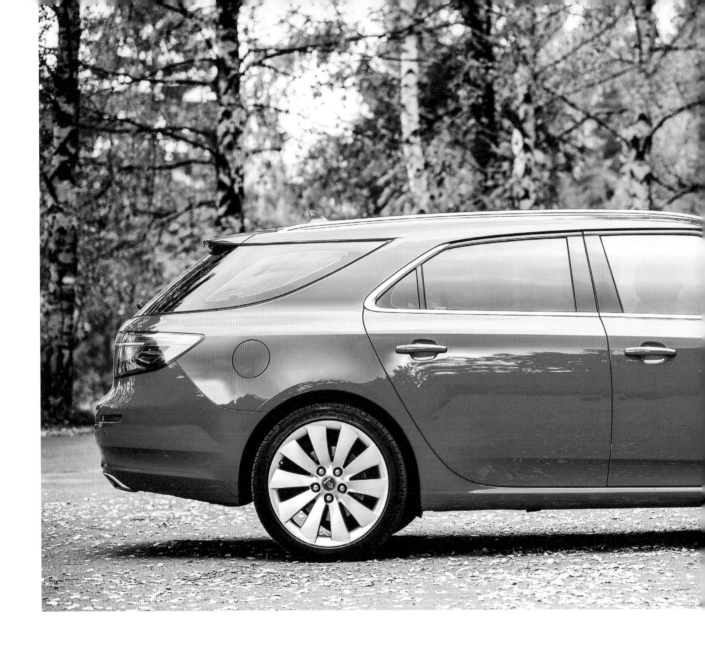

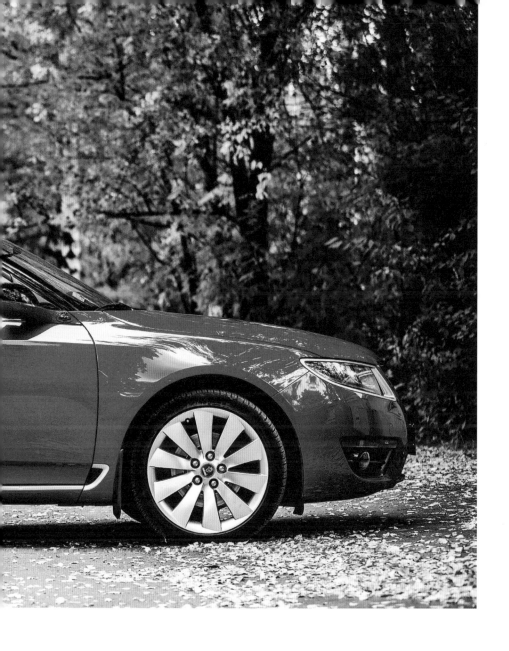

The 2012 Saab 9-5 Linear
SportCombi 2.0 TTid.

48

THE SAAB CAR MUSEUM

Should you want to know more about Saab, the best place to go is the Saab Car Museum in Trollhättan, Sweden. Your visit will be more than a tour in nostalgia, because here are people who know more about the brand than anyone else. And for Saab techno buffs, this is certainly the place to be. All those cars with their engine bays to peer into.

Yet for me, the most touching object on display is a company bicycle used by Saab's factory workers, reminding us that behind Saab's formidable technological innovations, there was always a human face, and there is the spirit of Saab.

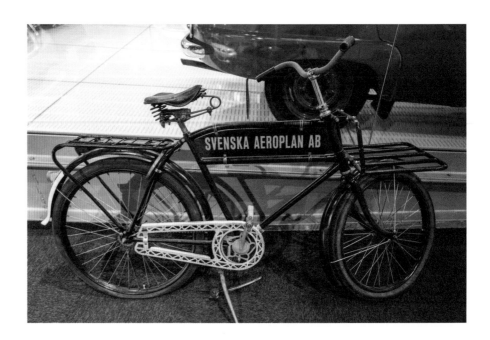

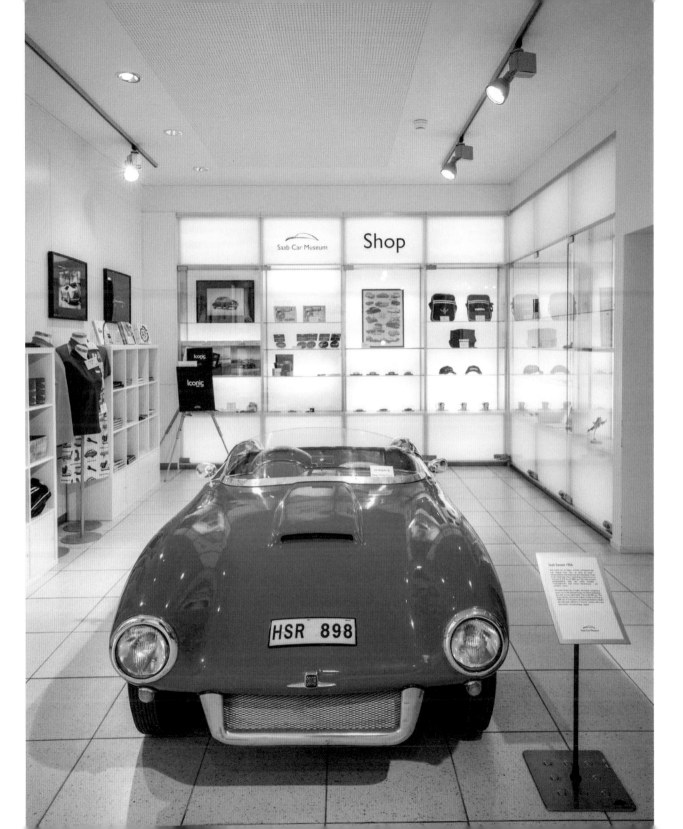

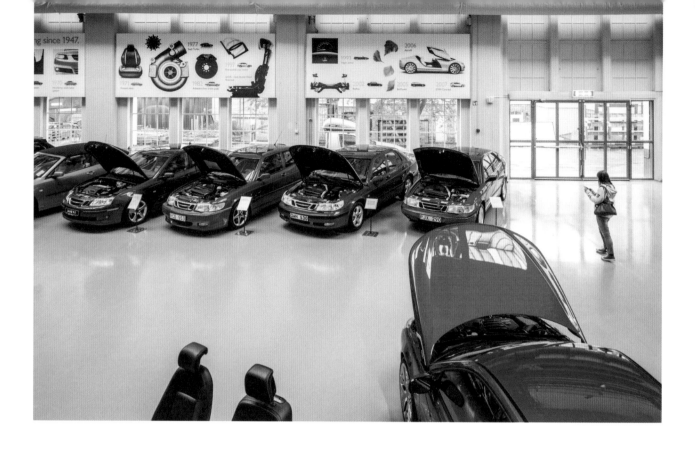

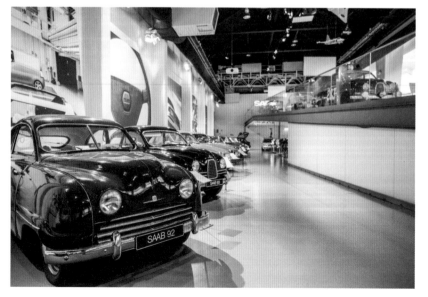

Various displays in the
Saab Car Museum,
Trollhättan, Sweden.

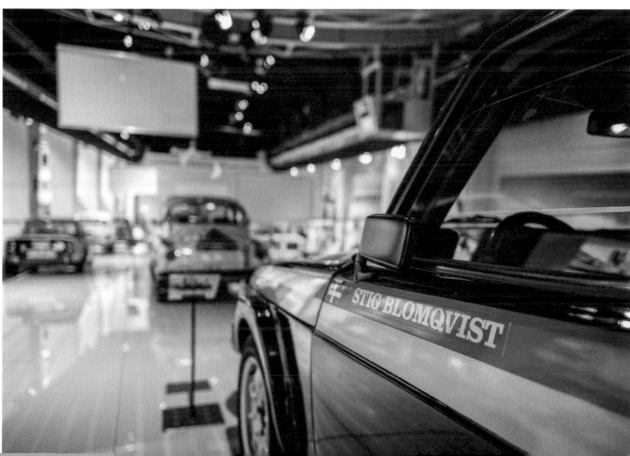

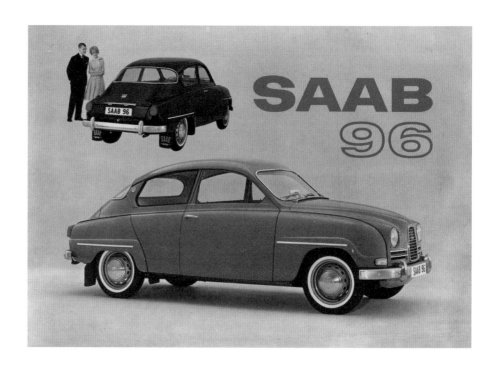

49

SHOULD YOU BUY ONE?

Post-GM Saabs can still be picked up for a song, but that will not last. They are a good investment. Pre-GM Saabs perhaps even more so, although they will cost more, especially the rare sports models and the convertible versions.

But investment opportunity is not the real reason for you to own a Saab. Like their first owners, you are demonstrating that you think for yourself. For you, the Saab owner, approval of the crowd is unnecessary.

Should you buy a Saab, you will have a car that grows on you — the way it drives, its idiosyncratic design features, its slim, elegant lines and, yes, its annoyances. It's rather like having a human addition to your

Above: Saab 96 brochure from the 1960s. Opposite: Saab 900 brochure from the 1980s.

Saab 900 Convertible - 1987
Supplement to the Owner's Manual

family. In a supermarket car park, you will notice how obese and sadly indistinguishable modern cars have become. And you will feel good as you climb into your Saab.

I own three classic cars, each lovely in their own way, but entirely different from one another. Just like my three children.

I'm now heading for the garage with three ignition keys in my pocket. Deliberately, I have not decided which one to take out until I actually arrive.

I'm now fishing in a glove box. Right. Where did I put those old Turbo shades?

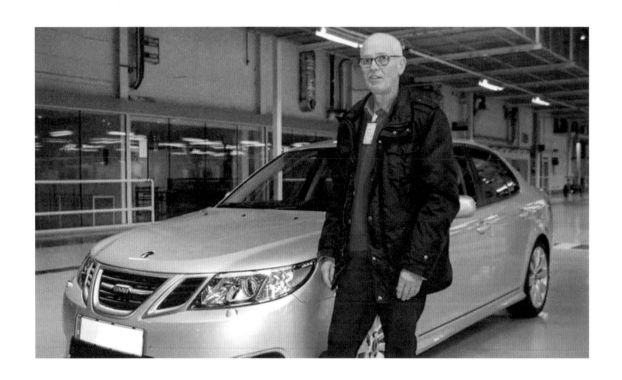

Mr Claus Spanggaard,
the winner of the auction
for the last Saab, with his
car in October 2019.

50

THE LAST EVER

If you want to make a Saabist green with envy, look no further than here. It is October 2019, and this is Mr Claus Spanggaard collecting his brand-new Saab, the very last made.

Claus's car is a 2014 9-3 Aero Turbo 4 with just 66 test-track kilometres on the clock. It was auctioned by NEVS, National Electric Vehicles of Sweden, who had bought up the Saab assets in 2012.

His winning bid was 465,000 Swedish kroner (£37,500), which was then donated by NEVS to University West, Trollhättan, for research into sustainability. That is very Saab.

ABOUT THE AUTHOR

Vaughan Grylls is an artist and writer. He lives in London and East Kent and has been a Saab enthusiast ever since he took delivery of a brand-new 900 at Zumbach Saab, New York City, in August 1984. Today Vaughan owns a 1987 Turbo Cabriolet with a matching pair of Turbo shades.

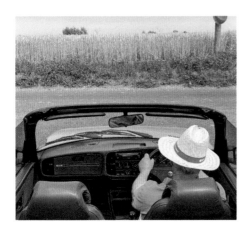

ACKNOWLEDGEMENTS

This book would not have been possible without Chris Redmond, Chairman of the Saab Owners Club of Great Britain and Martin Bergstrand, Vice-Chairman of the Svenska Saabklubben for their valuable comments and advice on the technical aspects and history of Saab, Susanna Small at Batsford Books for sourcing many of the images and Ferdy Carabott for resuscitating some ancient yet key ones. Last but not least, huge thanks to my editor Nicola Newman, for keeping this book on the road.

Vaughan Grylls

INDEX

First published in the
United Kingdom
in 2023 by
B. T. Batsford Ltd
43 Great Ormond Street
London
WC1N 3HZ

An imprint of B. T. Batsford
Holdings Limited

ISBN 978 1 84994 802 9

A CIP catalogue record for this book
is available from the British Library.

10 9 8 7 6 5 4 3 2 1

Reproduction by
Rival Colour Ltd, UK
Printed and bound by Toppan
Leefung Ltd, China

This book can be ordered direct
from the publisher at www.batsford.
com, or try your local bookshop.

PICTURE CREDITS

2, 20–21 top, 66 top left, 120 bottom Danita Delimont/Alamy; 7, 28–29 culture-images GmbH/Alamy; 12, 51 Heritage Image Partnership Ltd/Alamy; 14–15 RichardBaker/Alamy; 16, 98–99 Roman Stasiuk/Alamy; 17 Shiiko Alexander/Alamy; 18, 18–19 Martin Bergstrand; 19, 72, 75 top right and bottom Ferdy Carabott; 20–21 bottom, 66 bottom left, 78 right, 121 top REUTERS/Alamy; 21 bottom P Cox/Alamy; 22–23 Bob Masters Classic Car Images/Alamy; 24–25 Cavan Images/Alamy; 26 Tomas Johanson/Alamy; 28 VDWI Automotive/Alamy; 29, 110–111 imageBROKER/Alamy; 30 top and bottom, 46, 46–47, 70 bottom right, 79 top and bottom, 80 bottom, 88 bottom, 92 bottom Drive Images/Alamy; 33, 94 Cernan Elias/Alamy; 36–37, 107 left and right Motorsport Images; 40–41 Owe Andersson/Alamy; 42 top Jeppe Gustafsson/Alamy; 42 bottom Antony Nettle/Alamy; 49 Antiques & Collectables/Alamy; 50 top, 61, 91, 102, 113, 126 Vaughan Grylls; 50 bottom danny bird/Stockimo/Alamy; 52–53 top Motoring Picture Library/Alamy; 52 bottom hans engbers/Alamy; 54 Chad Ehlers/Alamy; 56–57 Skandix.de; 58 Bobby Bogren/Alamy; 62 top, 62–63 top, 62 bottom picturesbyrob/Alamy; 66–67 top right

pbpgalleries/Alamy; 66–67 bottom right, 80 middle Oldtimer/Alamy; 69 top Lars Johansson/Alamy; 68–69 bottom ZarkePix/Alamy; 70 top tommyscapes/Alamy; 70 bottom left FSM Photography/Alamy; 73 Robert Lloyd-Ashton/Alamy; 74 left and middle, 75 top middle Phil Talbot/Alamy; 74 right CNP Collection/Alamy; 75 top left Sibylle A. Möller/Alamy; 76 all images saabvsscepticism.co.uk; 78 left Steven Bennett/Alamy; 80 top Phil Brown/Alamy; 80–81 Coollife/Alamy; 83, 104 bottom left Patti McConville/Alamy; 84, 95, 96 TT News Agency/Alamy; 86–87 rep-your-hood.com; 88 top Michael Preston/Alamy; 100 Classic Picture Library/Alamy; 101 bottom MartinxFejer/EST&OST Fejer16080705; 103 Everett Collection Inc/Alamy; 108–109 PA Images/Alamy; 114–115 Johannes Bohnacker/Alamy; 116-117 CTK/Alamy; 118, 119, 201 top, 121 bottom Hemis/Alamy. All reasonable efforts have been taken to ensure that the reproduction of the content in this book is done with the full consent of the copyright owners. If you are aware of unintentional omissions, please contact the company directly so that any necessary corrections may be made for future editions.